DAVID HOCKNEY

FACES
1966-1984

DAVID HOCKNEY

FACES
1966-1984

Designed by David Hockney
Essay and Commentaries by Marco Livingstone

Published by
Laband Art Gallery, Loyola Marymount University
in cooperation with Thames and Hudson

This book is published in conjunction with the exhibition:

DAVID HOCKNEY: PORTRAIT DRAWINGS 1966-1984
Laband Art Gallery
Loyola Marymount University
Los Angeles, California 90045

January 30 — March 14, 1987

First published in the United States in 1987
by Loyola Marymount University and
Thames and Hudson Inc., 500 Fifth Avenue,
New York, New York 10110

First published in Great Britain in 1987
by Thames and Hudson Ltd, London

Library of Congress Catalogue Card Number: 86-83167

Printed in the United States of America

Cover: David Hockney, 1986

Foreword

When David Hockney first agreed to have an exhibition of portrait drawings at Loyola Marymount University, I was delighted, not only because I had always been drawn to this aspect of his work, but because I relished the opportunity to come into closer contact with an artist whose different styles of painting and drawing had made him something of an enigma in contemporary art. Unlike many of his contemporaries, he could not be pigeon-holed; moving with apparent ease and facility between naturalistic drawing (seen in many of the portraits in this catalogue) and an intriguing mix of other styles, he had left his critics confounded and his followers wondering what he would do next. In contrast to many artists who became ossified in one style and medium, he refused to stay within the formulas which brought him critical success in the past. Not only had Hockney moved between styles, he had moved back and forth across media: painting, printmaking, stage design, photography; what would the man do next?

As it turned out, our show happened at a time when Hockney was once again testing and pushing at the boundaries within which many of his contemporaries were constrained. During the time it took for this show and catalogue to become a reality, he had come upon another medium which he was exploring with great enthusiasm: photocopying. His ideas concerning this medium are more fully discussed by Marco Livingstone in this catalogue and will not be discussed here. However, because of his fascination with office copiers, the production of this book was profoundly influenced. What started out as a rather straightforward catalogue metamorphosed into a book which is quite remarkable both in its visual impact and in the freshness of the ideas which created it.

Considering most traditional book design to be dull and incapable of communicating his work in any meaningful way, Hockney has instead transformed the original drawings by enlarging them xerographically so that the line quality itself changes, as well as the space which envelops them. He wants not only to make the image work in a different medium — in a book rather than in a drawing on a wall — but to acknowledge the process itself, whether it is a xerox or the printing process. He reiterates that he is not interested in *reproducing* the image, but in *transforming* it.

Although many of the drawings reproduced in this book are actually in color, he decided not to print with color because he felt that it would detract from the dramatic impact and continuity of the book. Elsewhere, he says: "Colour is the most fugitive element of a picture. It's fugitive in life and its fugitive in the physical reality of the picture. We can remember that it was red, but we cannot remember exactly what kind of red; this is why I think black and white pictures work best, because, in a sense, we are more attuned to lines and what they do, than to colours and what they do."

Hockney says that he thinks he sees things differently from other people. "I've often thought about the way I see. For years, I've thought my eyes are funny or something. I kept thinking how much can you really see and what is it you really take in as your eye moves about focusing?" I think what he is trying to do is to make us see in a more profound way. Henry Moore says "Artists are the eyes for other people who don't have the time to spend looking at and finding out about nature. It's nature that you must be taught to see." Hockney has questioned ideas of linear perspective (which many people perceive as an accurate transcription of nature) held by artists since the Renaissance, and has instead used a cubist delineation of space which he feels approximates our actual lived experience as we move through time and space. Like Henry Moore, and like the cubists, he sees his system of seeing as part of a seamless web which encompasses all of life.

Many people have been instrumental in bringing this exhibition to fruition. First and foremost, I would like to thank David Hockney for his interest and enthusiasm in every facet of this book's creation, and Charlie Scheips and Richard Schmidt for their extensive help in the formation and production of this book. Peter Goulds of L.A. Louver Gallery conceived the idea for this exhibition and suggested it to David Hockney, and I am most grateful to him. Karen S. Kuhlman has been a pleasure to work with in the organization of the catalogue and show itself. Marco Livingstone's text has elucidated with clarity and insight Hockney's theories of portraiture and his relationships with his subjects. The Richard Gray Gallery in Chicago and the André Emmerich Gallery in New York have generously lent pictures to this show. Others whom I particularly wish to thank are: Paul Hockney, Warren Sherlock, Charles Gagan, S.J., Bob Cooney, Dick DuMont, Marc Nochella, the members of the LMU Advisory Board, Lisa Terzi, Katie Thorpe, Lynn Creighton, and many, many others too numerous to mention.

Ellen Ekedal
Director
Laband Art Gallery
Loyola Marymount University

A Life in Portraits
by Marco Livingstone

Depictions from life of family and friends have long supplied David Hockney with some of his most engagingly human and intimate subject matter. One of his earliest extant paintings, made in 1955 when he was still a teenage art student in Bradford, was a sensitive tonal portrait of his father. In spite of being regarded by critics as a Pop artist on his emergence from the Royal College of Art in 1962, even at that early date Hockney showed little interest in transposing images from the mass media, preferring to borrow, if necessary, from poetry, and to effect an alliance of direct observation with ideas either imagined or taken from memories rooted in his own experience.

In spite of his devotion to life drawing, Hockney cannot be said to have properly turned his attention to portraiture during the early 1960s. In the winter of 1959-60, during his first year at the Royal College, he made some painstakingly accurate drawings of skeletons that were a *tour-de-force* of technique, but these were studies not of people but of objects. The figures which populated early paintings such as the *The First Marriage (A Marriage of Styles)* 1962 or *Domestic Scene, Notting Hill* 1963, though based in part on firsthand studies of friends, were either too generalized to be identifiable as particular individuals or phrased so consciously as elements in elaborate stylistic games that it would seem an exaggeration to call them portraits. It was only in 1965, with his first line drawings in pen and ink, that Hockney began to make pictures of people that could be regarded as portraits in a traditional sense, as images, that is to say, that provided evidence both of the sitter's distinctive appearance and of his or her personality. His father, Kenneth Hockney, was once again the subject of one of the first of these: by the artist's own admission not a very penetrating drawing in its psychological insights, but one that tentatively set the terms for the figure drawings in fluid outline which began to pour from his pen in the following year.

All of the artist's portrait drawings were made in the presence of the sitter, for in Hockney's view a portrait by definition has to be done from life or very soon after. This, however, by no means excludes the possibility of incorporating elements from memory, since previous knowledge of how someone behaves or looks can alter one's apprehension of that person on a later occasion. Hockney is convinced that having recourse to information gathered from past experience, in conjunction with the evidence of the moment, has allowed him to make livelier and more animated faces than might otherwise have been possible.

Professional portrait painters, today as in the past, have tended to work on commission and in so doing they have frequently produced official emblems of the sitter's status or power, or at the very least reflections of their ideal self-image. The great portrait painters

such as Goya were able to transcend such circumstances and to produce psychologically incisive rather than merely flattering images. In lesser hands the results too often are dull and uninformative, telling us more than we might want to know about human vanity but revealing frustratingly little about more urgent matters, such as the sitter's emotional life or the nature of his or her relationship to the artist.

Recognizing the pitfalls of commissioned portraits, Hockney has consistently shunned such offers, preferring to choose when and whom to draw and to concentrate on drawing people who are already a vital part of his life. Almost all the drawings gathered together here still belong to the artist. Many of them, such as the portraits of his parents and those of his most valued friends such as Celia Birtwell, he has kept as much for sentimental reasons as for their intrinsic quality. Often, of course, the most revealing drawings are the ones of the people whom he knows most intimately. Hockney has made occasional exceptions to his general rule of not drawing strangers at their own request, usually out of an appreciation for the person's work; this was the case, for instance, with his drawing of composer Harrison Birtwistle in 1970, of W. H. Auden in 1968, or of the writer and academic Sir Isiah Berlin in 1980. Hockney remarks of commissions:

Nobody asks now because it's known that I won't do them, but many years ago people thought, 'Oh, he'll paint portraits.' I didn't want to do that, and I let it be known that I did not wish to be involved with those problems, really. That's all. But naturally I've always liked drawing people, so one tends to draw one's friends and the people one knows around you — anybody does. Occasionally when one wants to meet people it's a nice way if some-body has asked you to draw them and you'd like to meet them anyway.

In Hockney's view there are certain obstacles to be overcome in drawing people on one's first encounter with them. Although the artist might feel that he already knows some-thing about them through their work, their faces will not be sufficiently familiar to him, even if he has previously seen photographs of them, to be able to draw them without stumbling over the task of first capturing their features.

I think the way I draw, the more I know and react to people, the more interesting the drawings will be. I don't really like struggling for a likeness. It seems a bit of a waste of effort, in a sense, just doing that. And you'd never know, anyway. If you don't know the person, you don't really know if you've got a likeness at all. You can't really see everything in the face. I think it takes quite a lot of time.

There are other rewards, too, in repeatedly drawing the same person over a period of time. A natural by-product of the activity has been that each drawing potentially captures another facet of each sitter, the process of aging, and their changing moods, while also charting the shift in their relationship with the artist. The painter who in the late 1960s was the subject of a film called *David Hockney's Diaries* agrees that the totality of

his drawings constitute a kind of visual diary of his life, although he maintains that the same would hold true for any artist who has set out to depict the visible world. There are, of course, those critics of Hockney's work who have ungenerously seen this absorption in his personal circumstances as evidence of a narcissistic self-obsession. I would prefer to turn this interpretation on its head, for in my view one of the great strengths of the artist's work has been his devouring curiosity in the life around him. Christopher Isherwood remembered that on one of his first meetings with Hockney, the artist set himself the task of making a drawing of every object in the motel room in which he was staying. It is thanks to his unflinching delight in the act of depiction and to his constant practice of drawing that he has been able to continue reinventing for himself, according to the circumstances, the most appropriate means of recording his observations. It is this process, in fact, that has propelled his work forward not according to the dictates of a self-proclaimed avantgarde but as the result of a personal vision and idiosyncratic imagination.

In his foreword to Jeffery Camp's manual, *Draw: How to Master the Art,* published in 1981, Hockney began with a comparison of learning to draw with learning how to write. The difference between the two, he remarked, is that in writing it is above all the beauty of the ideas which one enjoys, whereas with drawing it is the beauty not only of the ideas but of the marks themselves and of the feelings that they represent. This may seem an oversimplification, but it does highlight the essential subjectivity which for Hockney has always characterized the act of making a depiction. Even when his work was at its most classicizing, in elegant and controlled line drawings of the later 1960s and 1970s such as the 1970 portrait of Cecil Beaton, his hand was guided as much by his feelings towards the person portrayed as by a desire to represent his appearance in as economical a manner as possible. With Hockney's move in recent years towards an ever greater subjectivity of vision, his use of this admittedly more detached and restrained techique has become less and less frequent.

I don't generally draw quite like that now, in the sense that somebody sits there. And to make line drawings like I did, you have to look rather hard, and draw rather slowly the line, and I draw rather rarely that way now, very, very rarely. In a way, what I have been trying to move away from is the fixed viewpoint. Well, that kind of line drawing on the whole works because you feel it's accurate, you feel the line has got the volume, or the line has got the person. The line is doing all the work. The viewer knows that. And somehow the way the line is used there I feel I've explored. I'd rather explore it another way now.

The photographic experiments that Hockney has been pursuing obsessively since 1982, a rephrasing of the multiple viewpoints of Cubism in the form of composite images, have so fundamentally altered his conception of the kind of information that one can convey in a picture that he has felt compelled to develop equivalent techniques in his

drawing and painting. His discoveries with the camera, and the theories he has developed on the advantages of a "moving focus" over the fixed one-point perspective devised in the Renaissance, have effected startling transformations in his hand-wrought images.

The photographic work affects everything. In a way what I was attempting to do was to make a new kind of pictorial space that photography could use. Well, I think I began to do that, really. Once you transform photography in that way, you transform all pictures, don't you? The difference is that you are in one picture — the space it's about contains you — whereas the other does not. The traditional one-point perspective picture is of a space that does not relate to you. You're in a separate space. Picasso's space engulfs you, you're in it. It's very different.

It took me a long time to understand what Juan Gris meant when he said, 'Cubism is not a style, it's a way of life.' I understand what the statement means now. He's right. But in a way I think this has been a great problem. Cubism is a style, but not in an ordinary sense. It's a very different way of looking and depicting, and as such it's not very well understood yet. People still refer to an ordinary, conventional picture as if it's very real.

In responding to any art, the viewer must begin by yielding to the conventions that the artist is using. Essentially this is simply the equivalent in painting and drawing to what Coleridge termed 'the willing suspension of disbelief' in literature. As most of us, however, have been accustomed to regard as 'realism' a direct form of representation based on a fixed position, any idiom based on Cubist notions is still likely to be unfamiliar and in the first instance to seem artificial and willed. Just as Hockney has been training himself to draw and to conceive of space in more fluid terms, so we as viewers are now in the position of having to learn to *look* at pictures in a different way.

In a way modern art hasn't triumphed yet! Because we're still stuck with the Renaissance picture — which is the photograph — and we believe it's the most vivid representation of reality. Until that alters, we're stuck. It's a naive idea, essentially.

The relationship between the hand-drawn and photographed image has constituted one of the central debates within Hockney's work for more than two decades now, beginning with his first extended stay in Los Angeles in 1964, when he began regularly to rely on snapshots as reference material for the making of his paintings. By the end of that decade he had developed a form of naturalism which owed much to the 35mm camera and which brought him close to the tenets of Photo-Realism, although only rarely did he base an entire canvas on a single photograph. In spite of the fact that he took more and more photographs as time went on, as recently as 1980 he remained adamant that it was not sufficient simply to record through the lens of a camera: the hand, not just the eye, had to be involved in order to achieve a synthesis of vision and emotion. In 1982, when he

began to produce complex picture puzzles in the form of a grid of Polaroid photographs, the camera for a time became his preferred tool as an artist, manipulated precisely as a means of enlarging the possibilities of depiction. During this past year he has begun to work with an even more direct form of printing, the photocopier. None of these activities, however, have changed Hockney's mind about the pre-eminence of the hand-drawn image, although there is no doubt that the evolution of his drawing style owes much to his discoveries in these other media.

Hockney's current experiments with xeroxes, which he calls *home made prints,* have already begun to have repercussions on other aspects of his work, including his ideas both about drawing and about catalogue design. He has bought himself four photocopiers, each of which has particular functions and attributes, and has begun to use them as a direct and spontaneous way of producing limited edition original prints that could not have come about through any other process. Starting in every case with an image freely and vigorously drawn on a sheet of paper, he photocopies this in a chosen colour, perhaps passing it twice through the machine in order to intensify the hue. He then draws a separate element on another piece of paper, duplicating this in another colour on the pre-viously photocopied sheet. This process is repeated through perhaps ten printings in much the same way that he might previously have had a lithographic printer produce an image from a number of individual plates. The finished print is not a copy of anything else, for it exists only in that form, the result of layer upon layer of colour. To Hockney these prints are intricately bound with his drawing, for in his view what he has been doing is drawing 'inside' the machine.

It was just a hunch. I thought the machines were not quite what the manufacturers said they were, so I started playing with them and within three weeks I realized that nobody had really explored them very much when compared to what I was getting out of them.

The xerox machine is really fascinating me, because I realize it's a camera and a printing machine. It's not a copier — I mean, it's not a copying machine — and the implications of that are fascinating me. That's what I've been delving into. The area even of what is a reproduction I think is an area that artists have to deal with, and I find myself strongly drawn to those questions. The xerox machine opened up an amazing area that I certainly didn't think was there. Nobody else did, I don't think. It's a totally new kind of printing that is very beautiful if you know about it, if you know what to do.

Photocopying techniques have come directly into play into Hockney's design for this book. Having decided that drawings often appear diminished in their power or difficult to see when reproduced — because, for instance, so much of the page will be squandered on blank paper — Hockney wished to represent each portrait drawing simply by a detail of the face, enlarged to nearly life-size so that it would fill the entire page. In all cases the

heads have been repeatedly enlarged on the photocopier, sometimes from the drawing itself and at other times from a photograph of it, gradually changing the quality of the line. Given that any reproduction entails treating the image at one remove from the original, Hockney decided that it would be preferable to make a virtue of this fact and to use drawings made over a period of nearly twenty years as the raw material for a new sequence of images that is complete unto itself. He has, in effect, re-drawn each of the faces.

As anyone who has played with a photocopier will have discovered, each time that an image is duplicated it is slightly degraded in definition, particularly if it is being enlarged at the same time. Hockney has made this characteristic a virtue. The head of Celia which now appears to gaze towards her young son is as brutally reduced to black and white as if it had been rubber-stamped onto the page. Claude Bernard's flattened image looks as though it has been gouged out as a woodcut. Even the line drawings, which best retain their definition, seem unfamiliar in their monumentality and in the boldness, even ferocity, of some of the magnified marks. Each image has taken on a new life and adopted a different identity, transformed by the same freedom of gesture that is one of the inescapable characteristics of Hockney's draftmanship in the 1980s.

In concentrating one's attention entirely on the heads, Hockney, with a powerful simplicity, makes the vital point that portraiture constitutes a confrontation between two personalities: first between the artist and sitter, then between the sitter and the spectator. In using his design to blur the distinction between one medium and another, and to pair images produced years apart from each other and in varied techniques, reformulated as an altered set of marks, he also makes a strong case for all of his work to be seen as facets of a single unified activity. Hockney says that it is only in the last two years that even *he* has begun to appreciate the subconscious interconnections that make sense of what at times has seemed like a disparate *oeuvre.*

I think the thing that runs through everything is, in fact, a kind of attitude about space. It's the thing that links everything: photography, theatre, drawings, paintings, prints. I think it's all in the early work as well. People trying to get out of pictures. People trying to make pictures bigger. Pictures in front of pictures within pictures. I don't think it was that conscious early on, but it's certainly there, it's a similar subject and I think now I can see myself, I can feel it myself.

The pictures that follow seek to overturn a great many preconceptions not only about the continuity of Hockney's work, but also about the function of reproductions. If it is not enough, as the artist seems to suggest, simply to present a pale approximation of the appearance of the original, then means must be devised to guarantee the lasting potency of its physical presence and of its hold over our imagination. In this way the work of

art may yet retain what Walter Benjamin so aptly termed its 'aura': not just in spite of but *by means of* collaboration with the forms of mechanical reproduction which may once have seemed to pose such a threat. Thanks, moreover, to all this machinery — the camera that photographed the drawing, the photocopier that enlarged the photograph, and the printing presses that have made widely available these photocopied enlargements — we are brought once again into intimate contact with the human presences wrought by the artist's eye, mind and hand.

PLATES

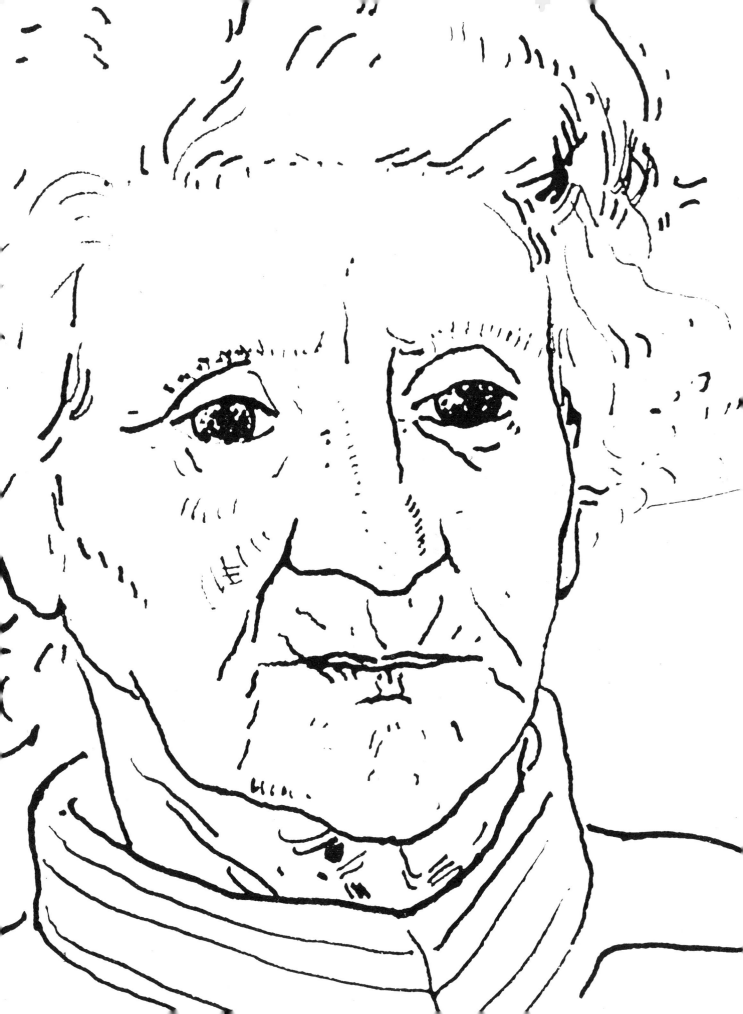

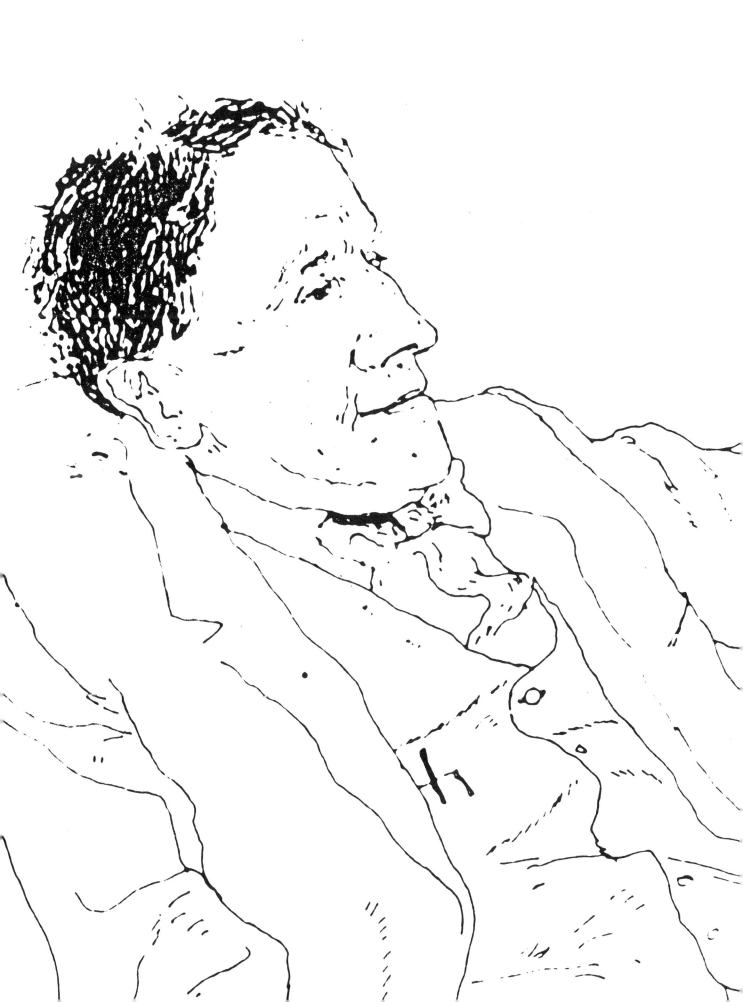

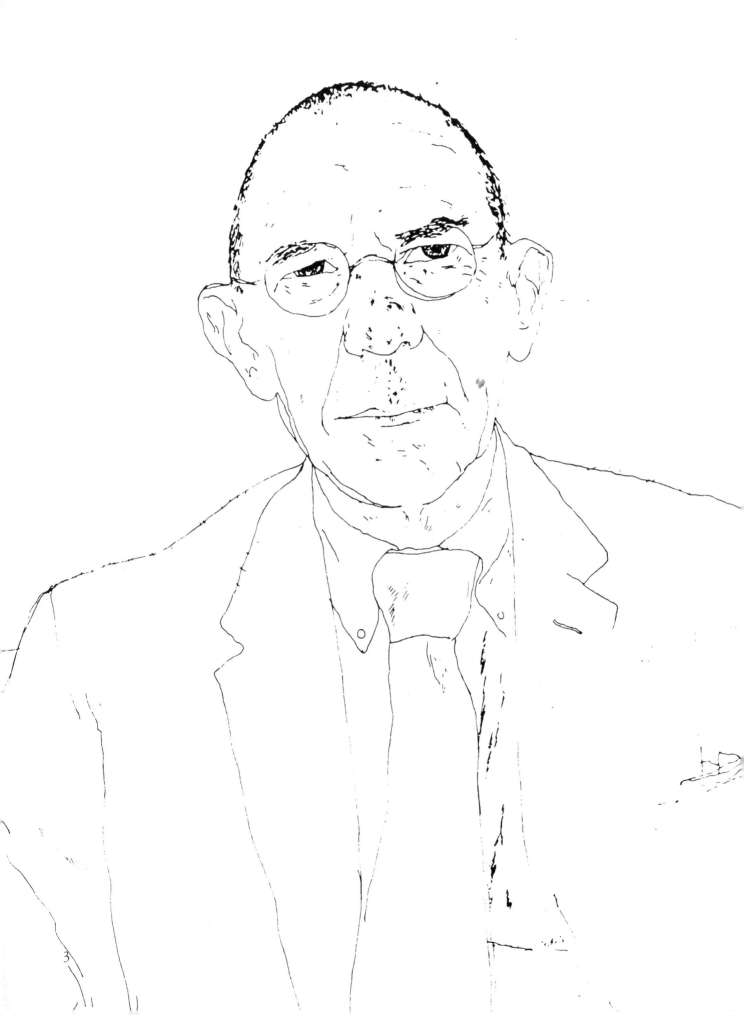

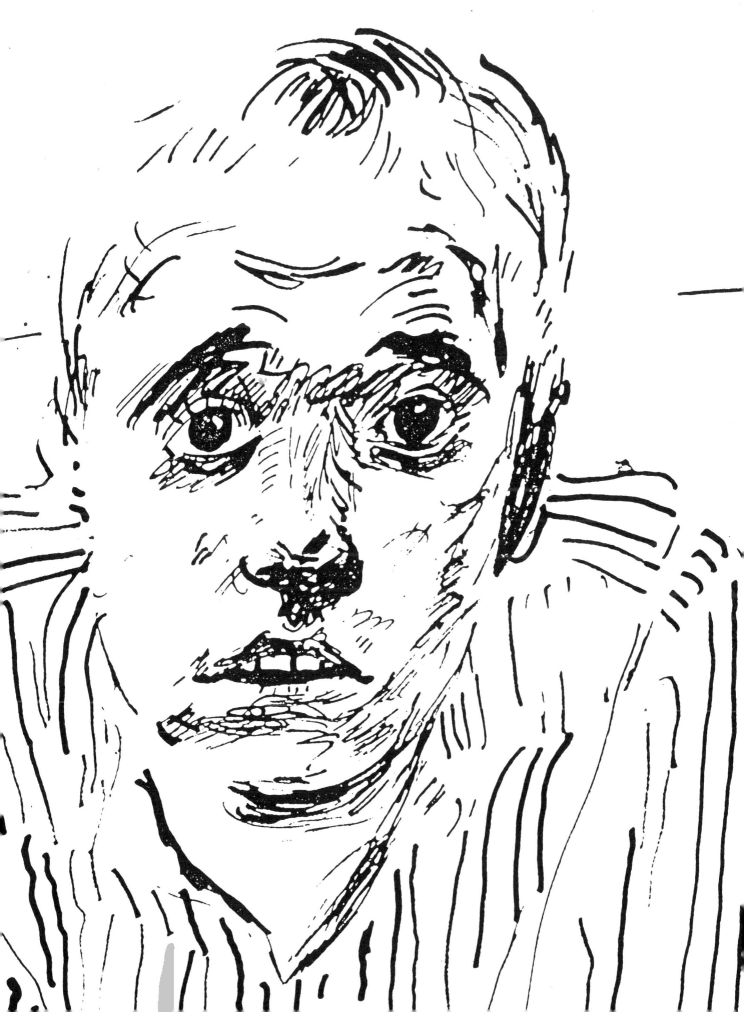

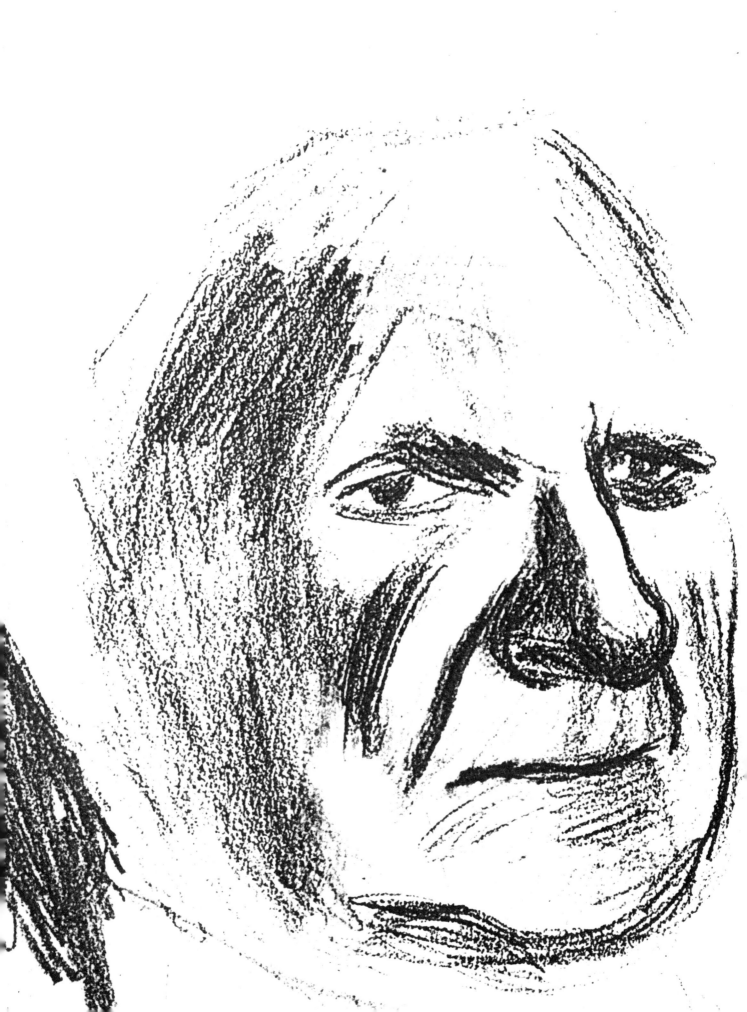

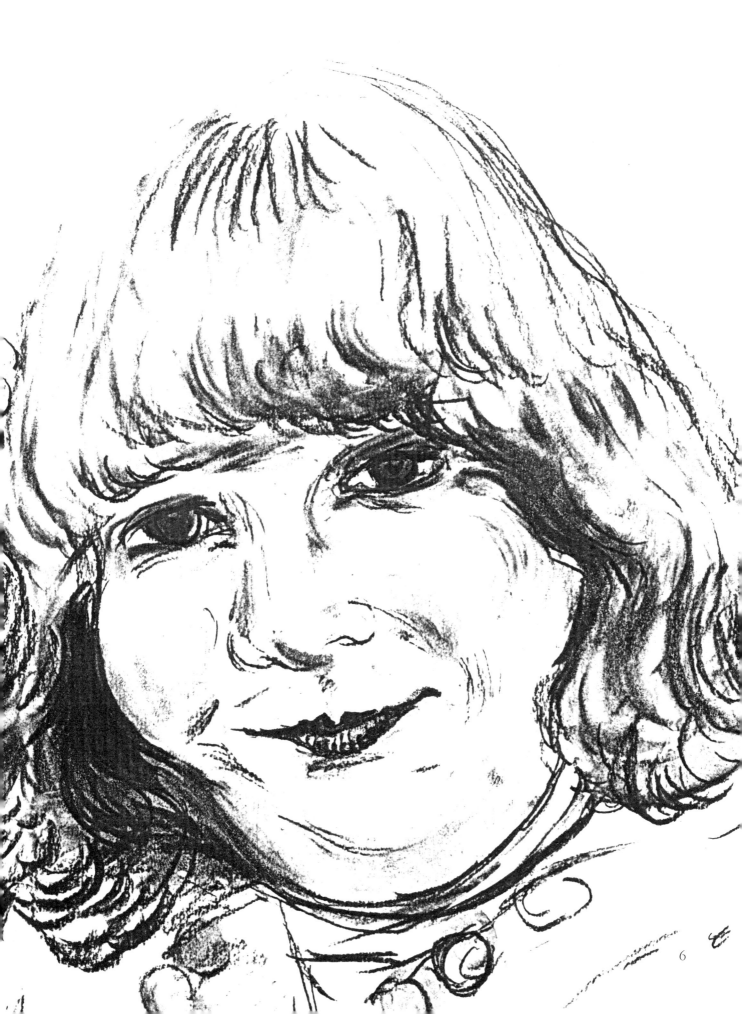

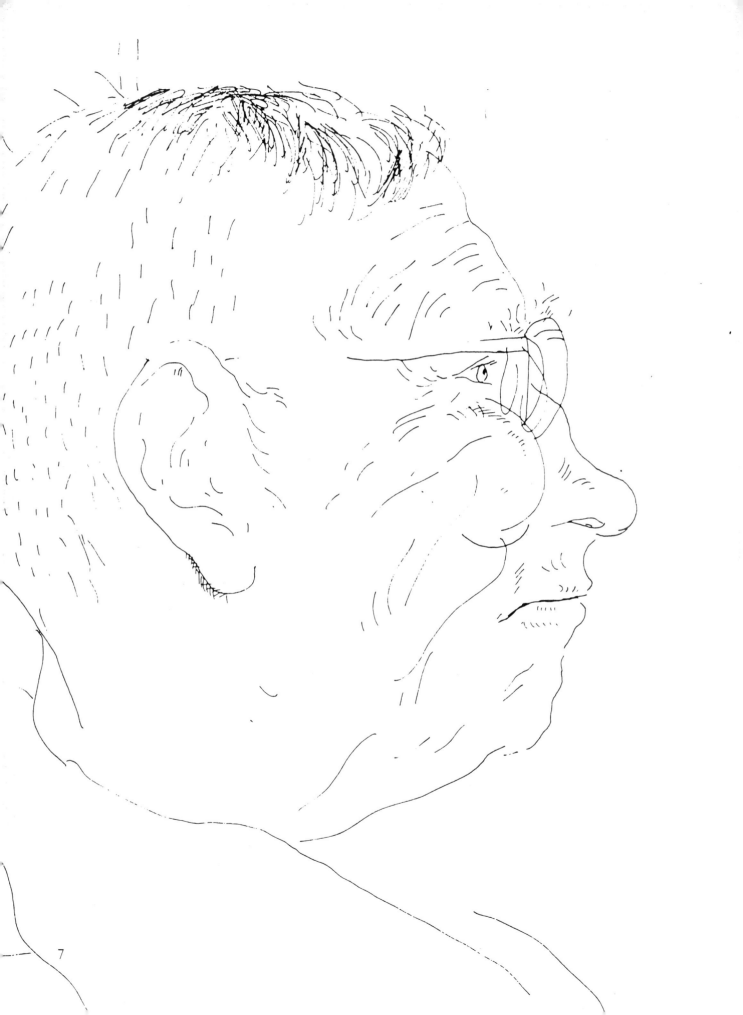

7

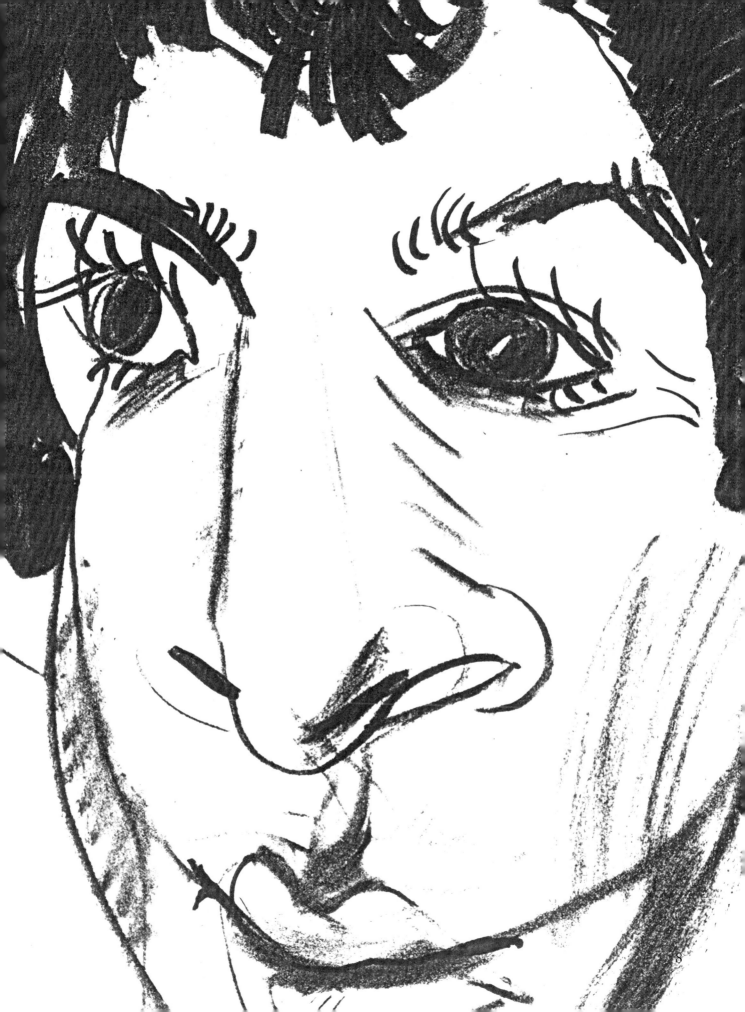

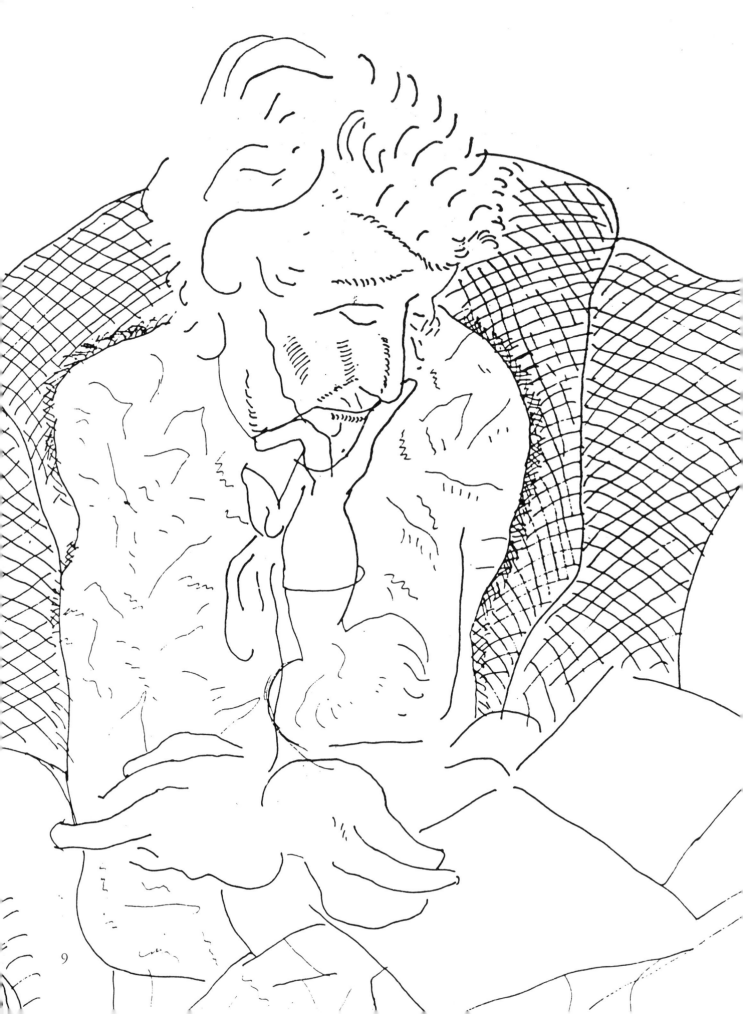

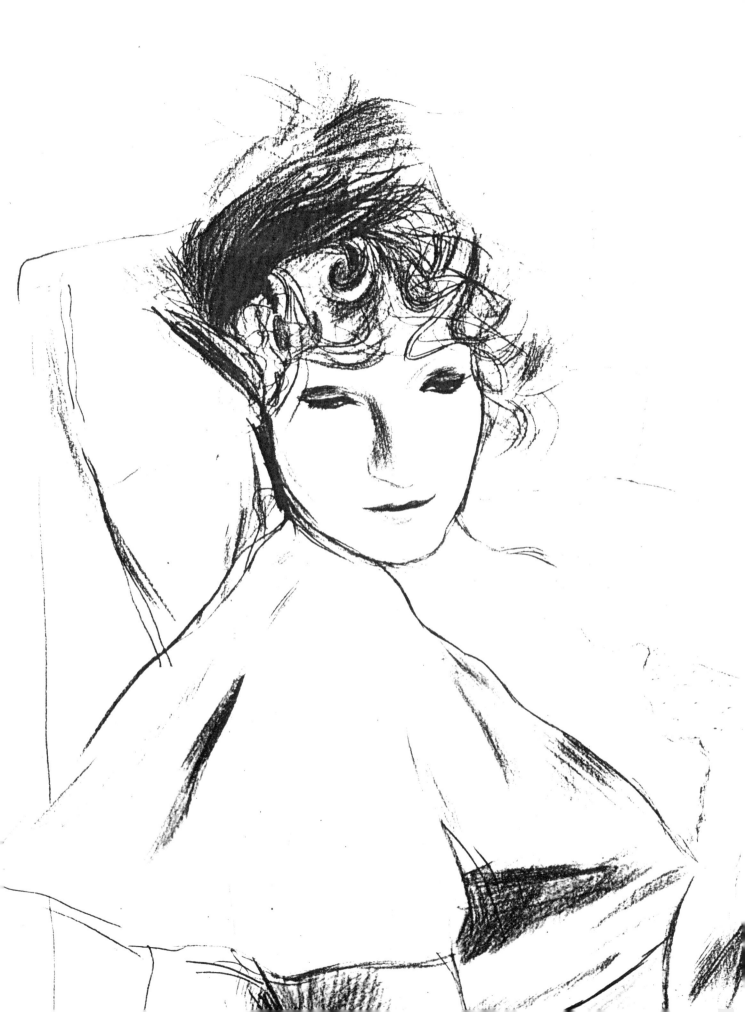

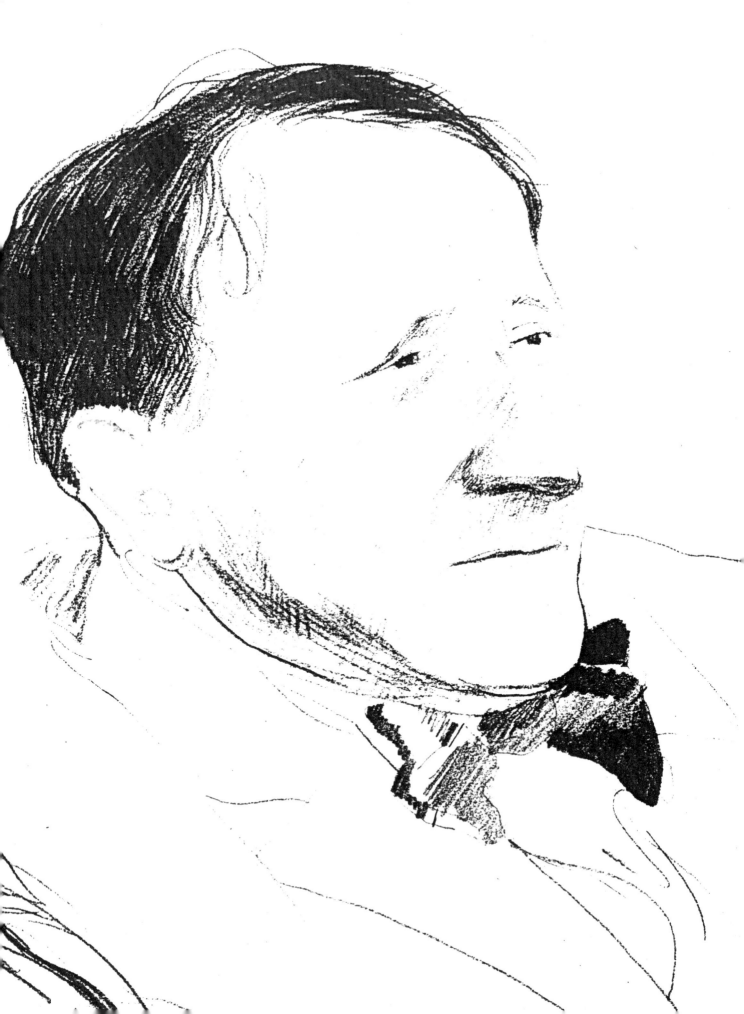

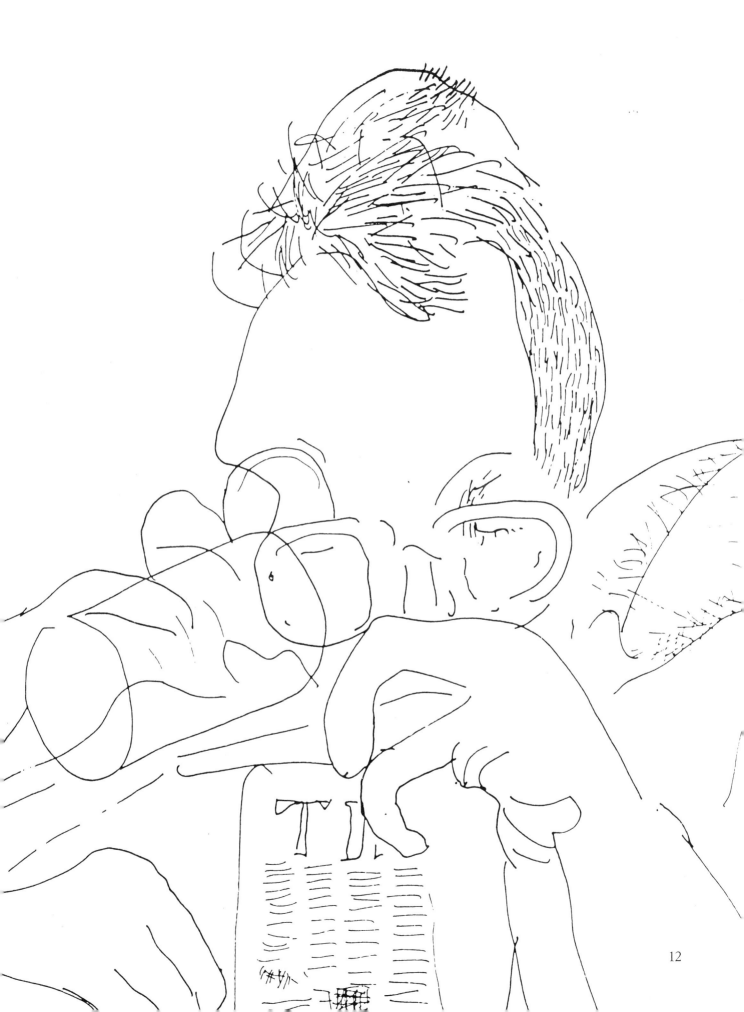

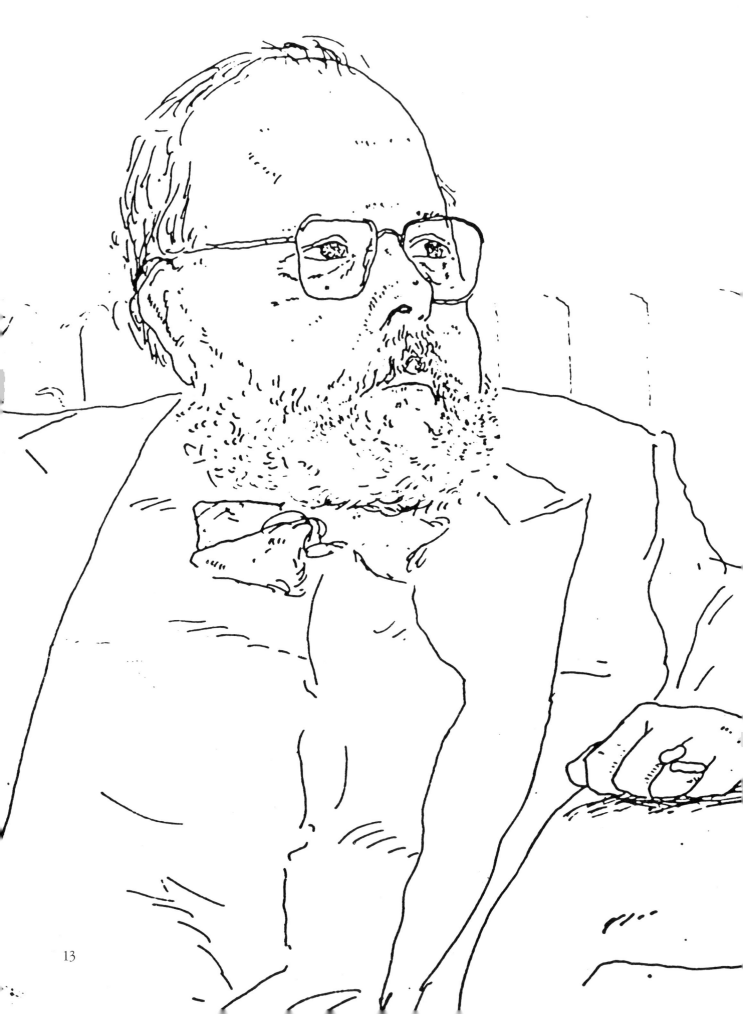

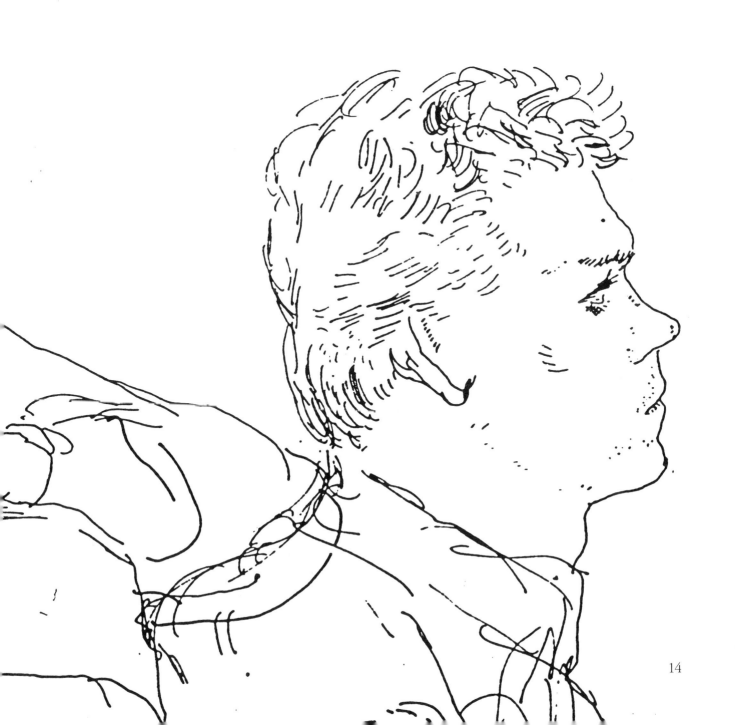

14

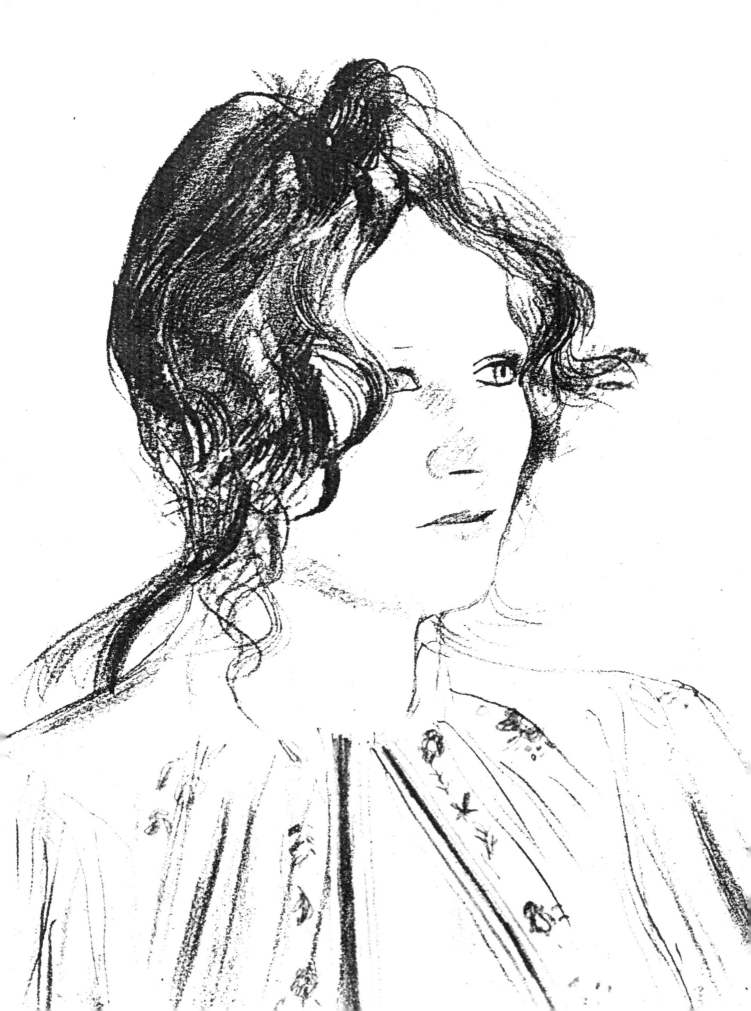

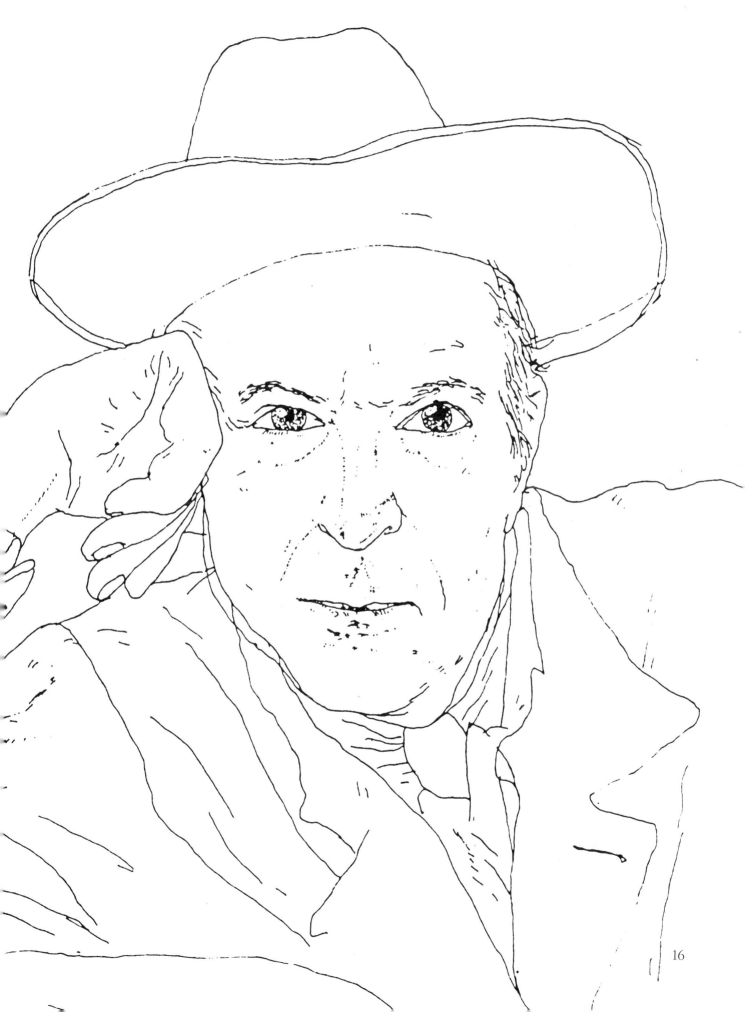

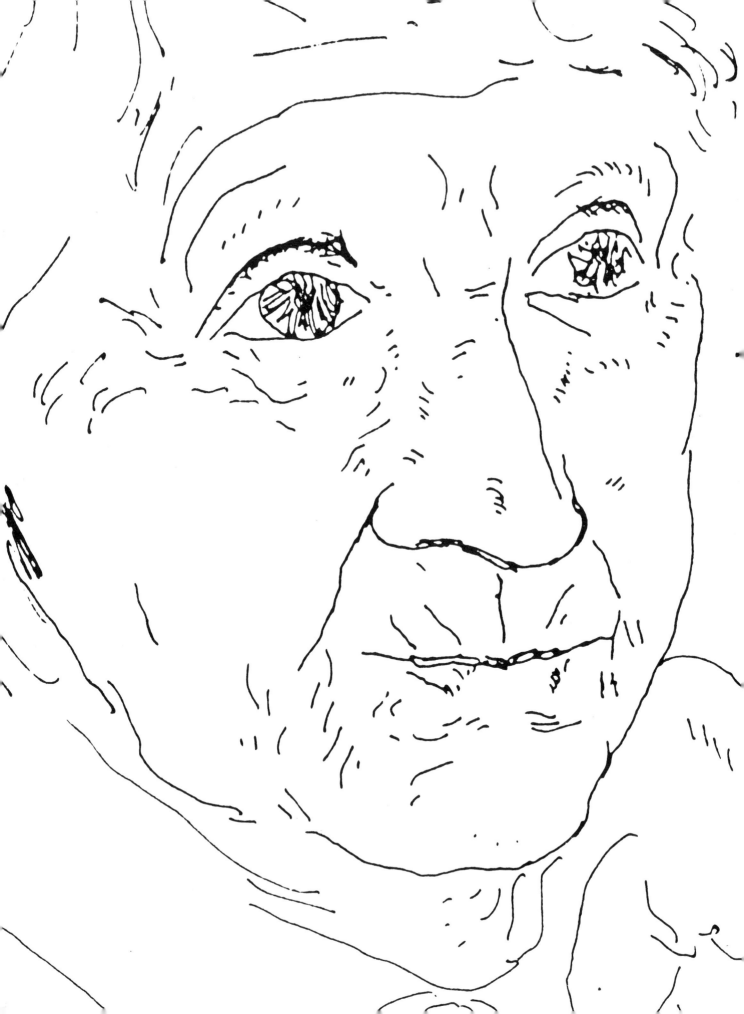

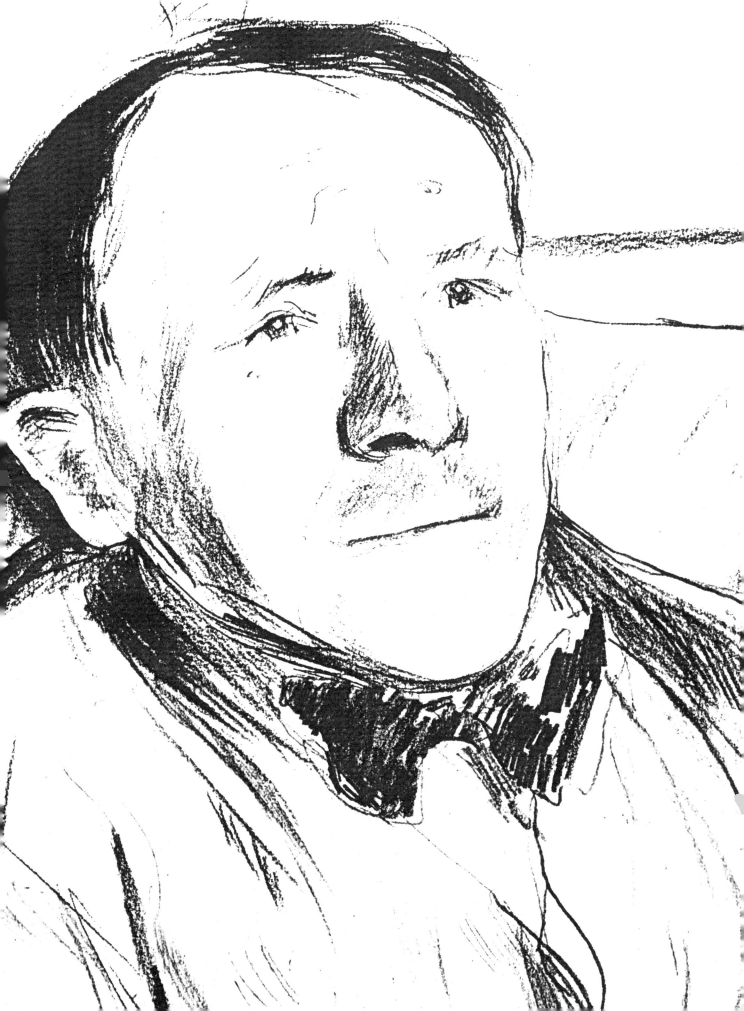

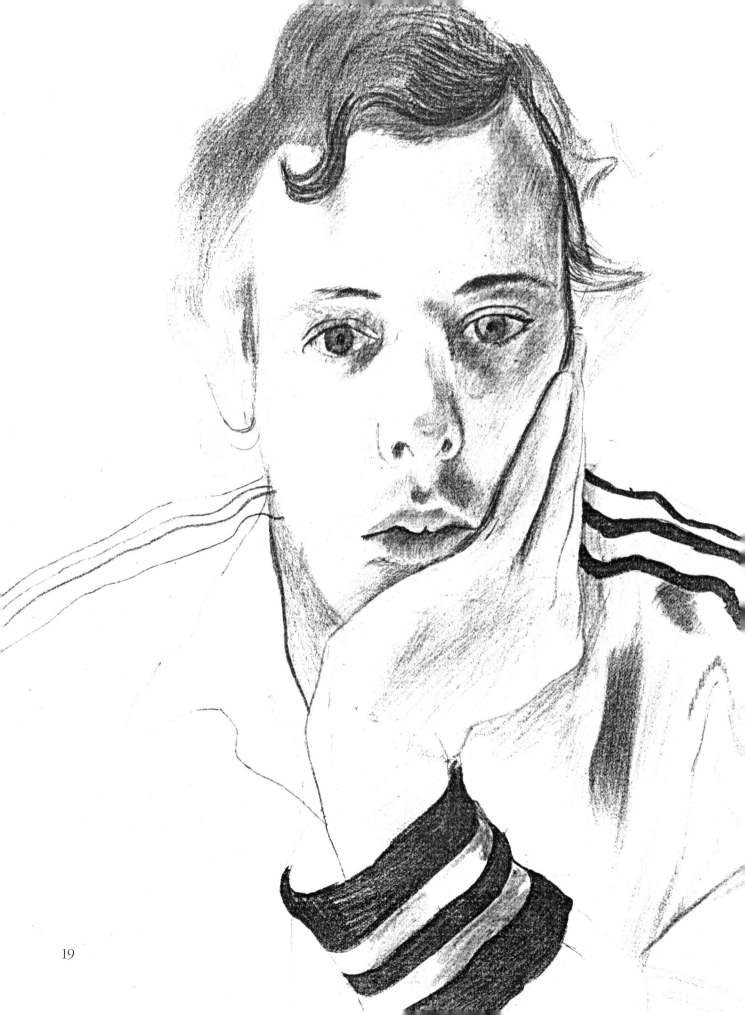

19

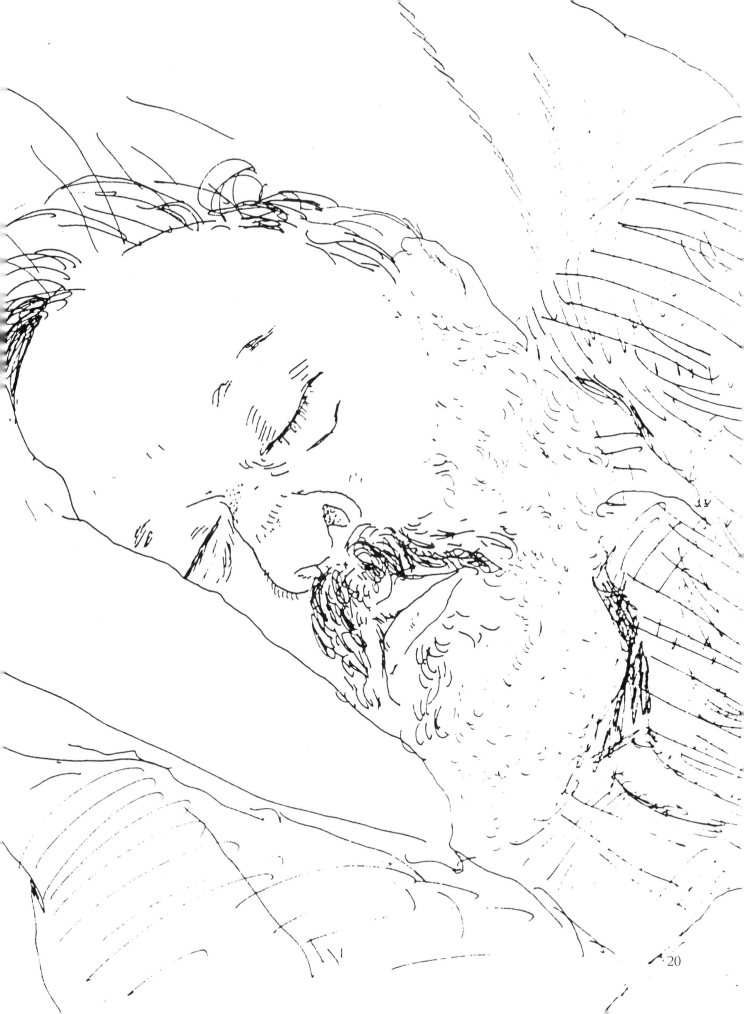

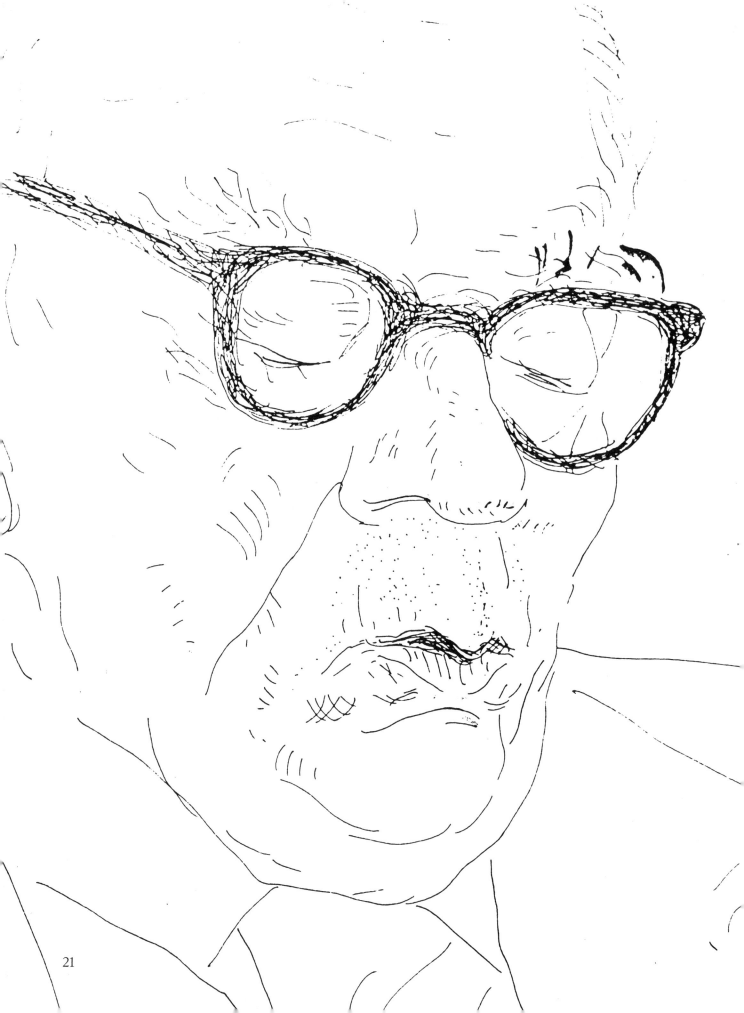

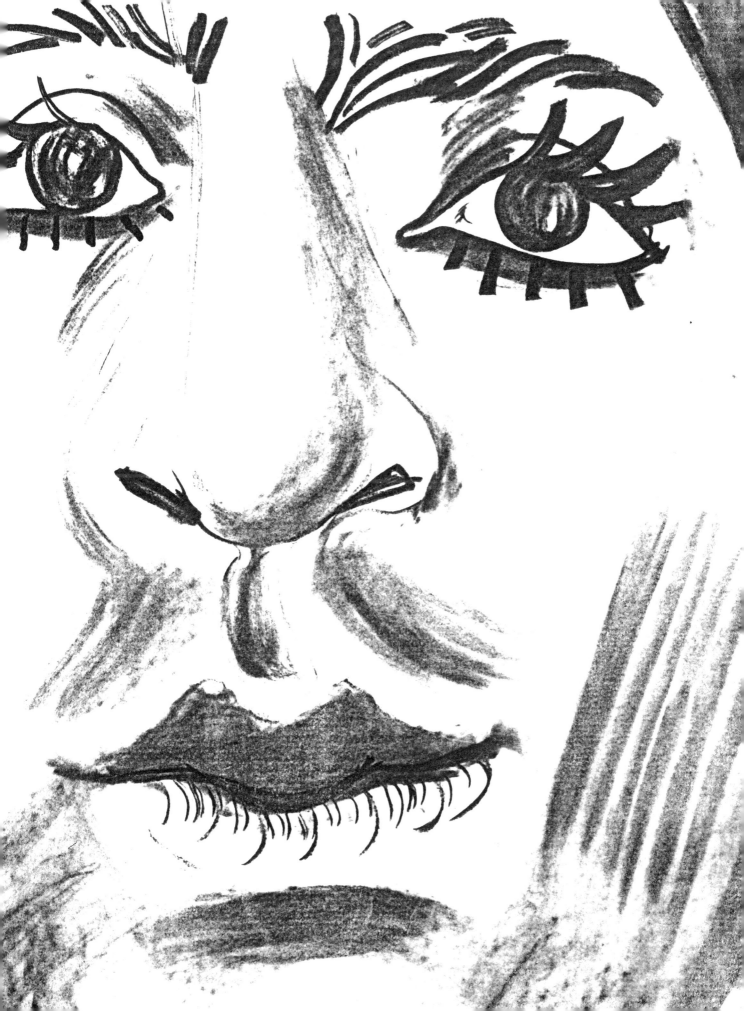

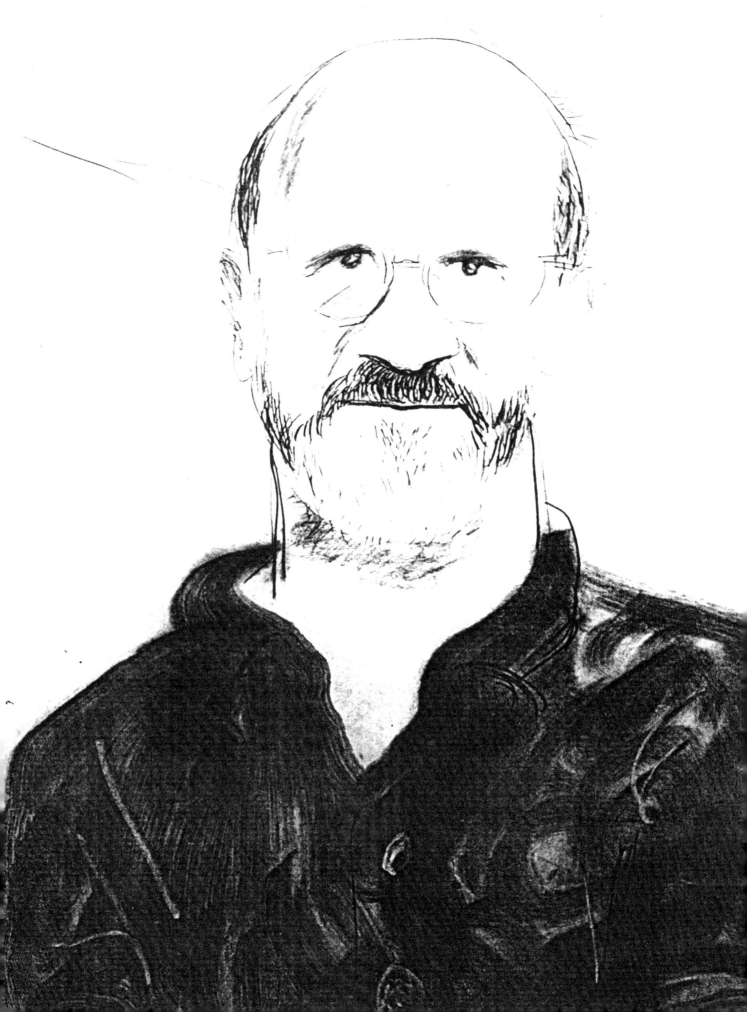

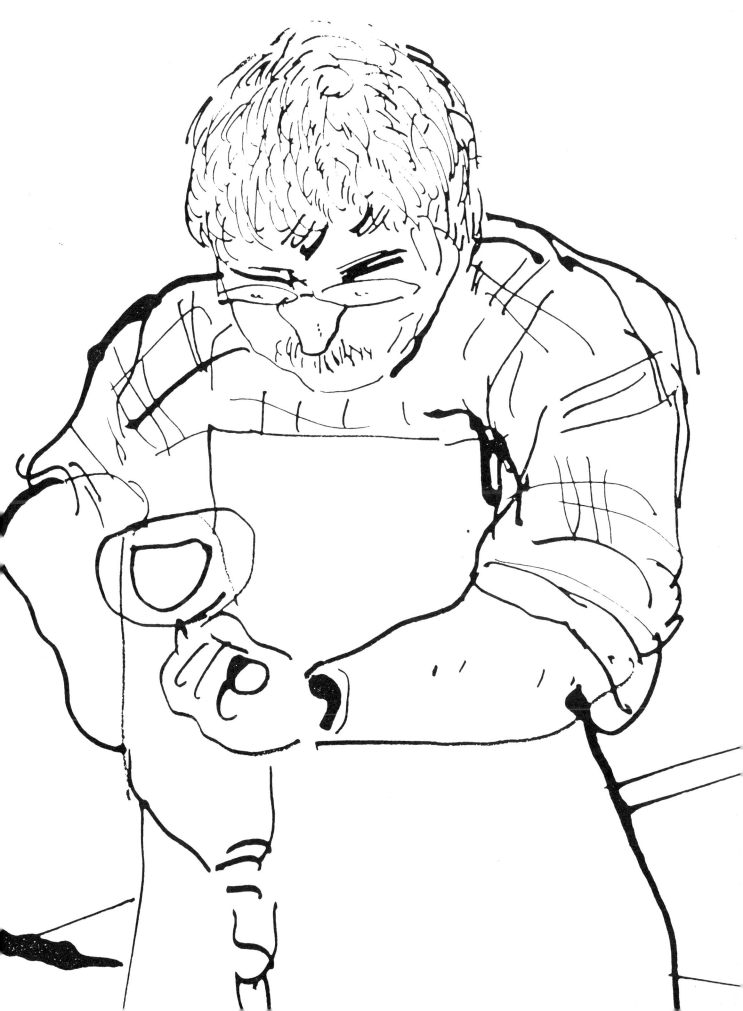

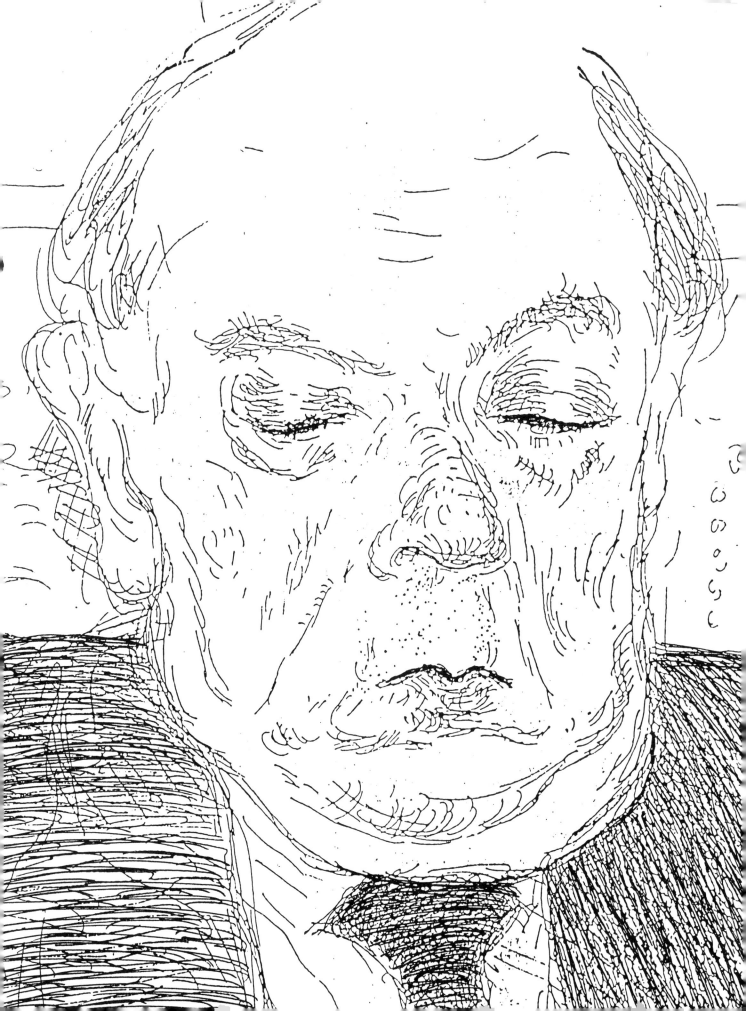

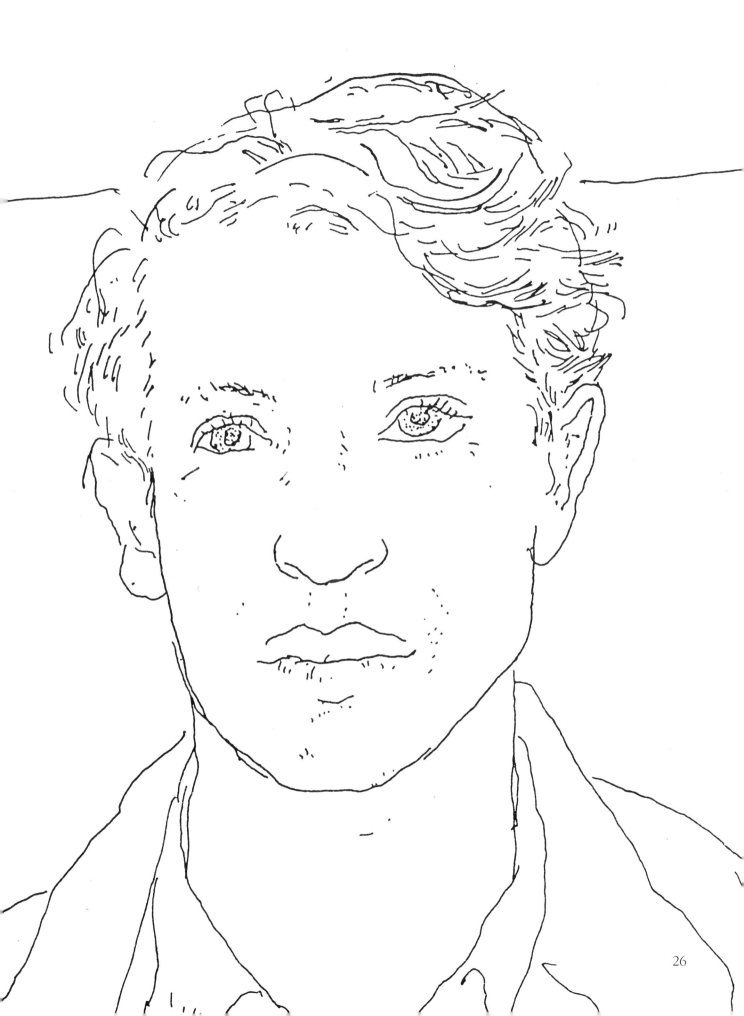

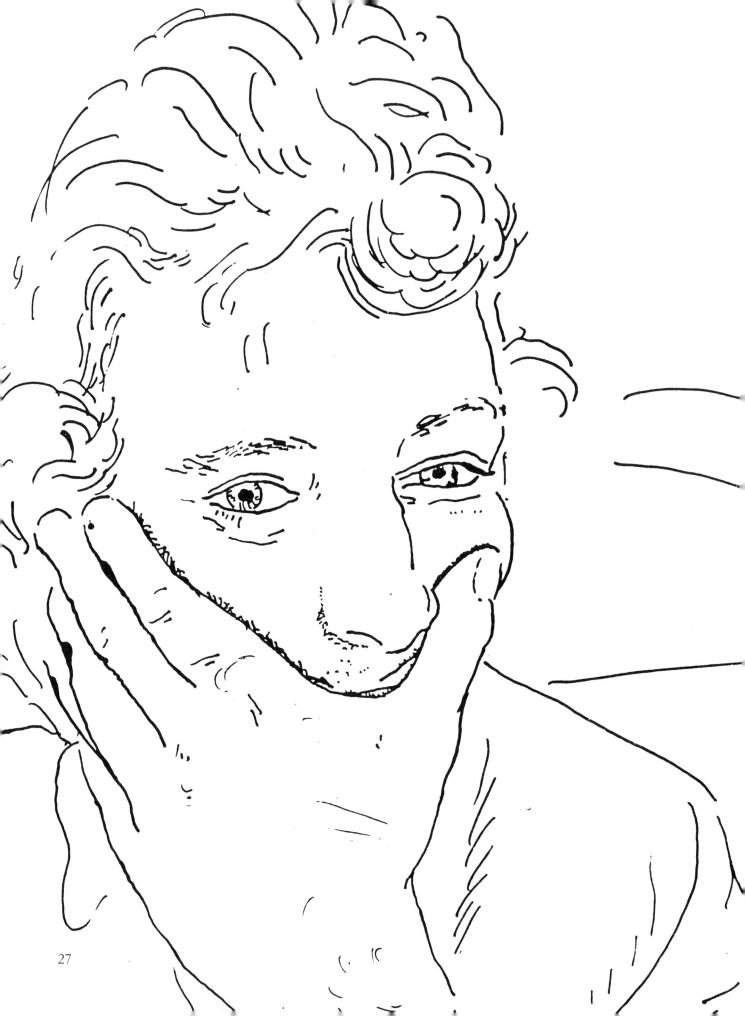

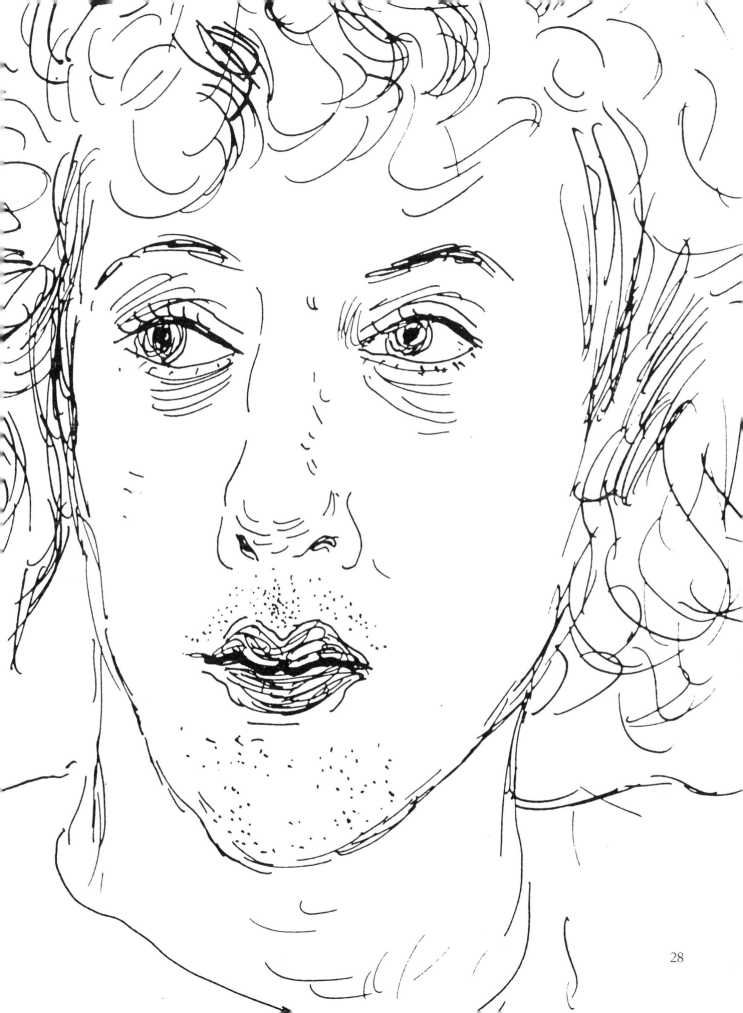

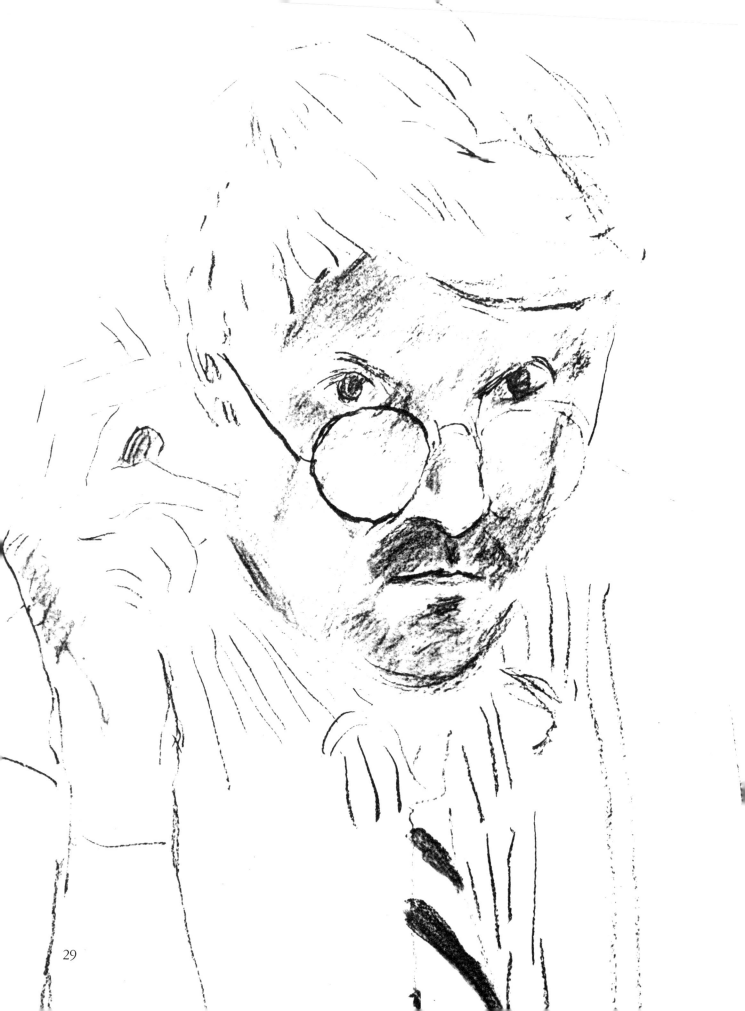

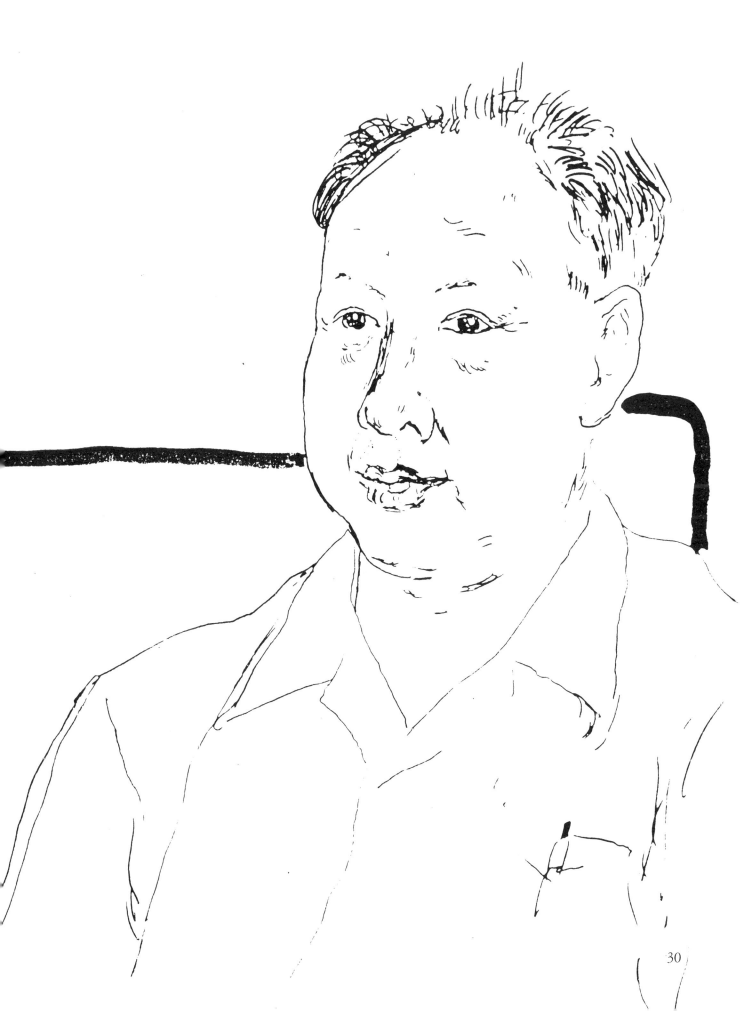

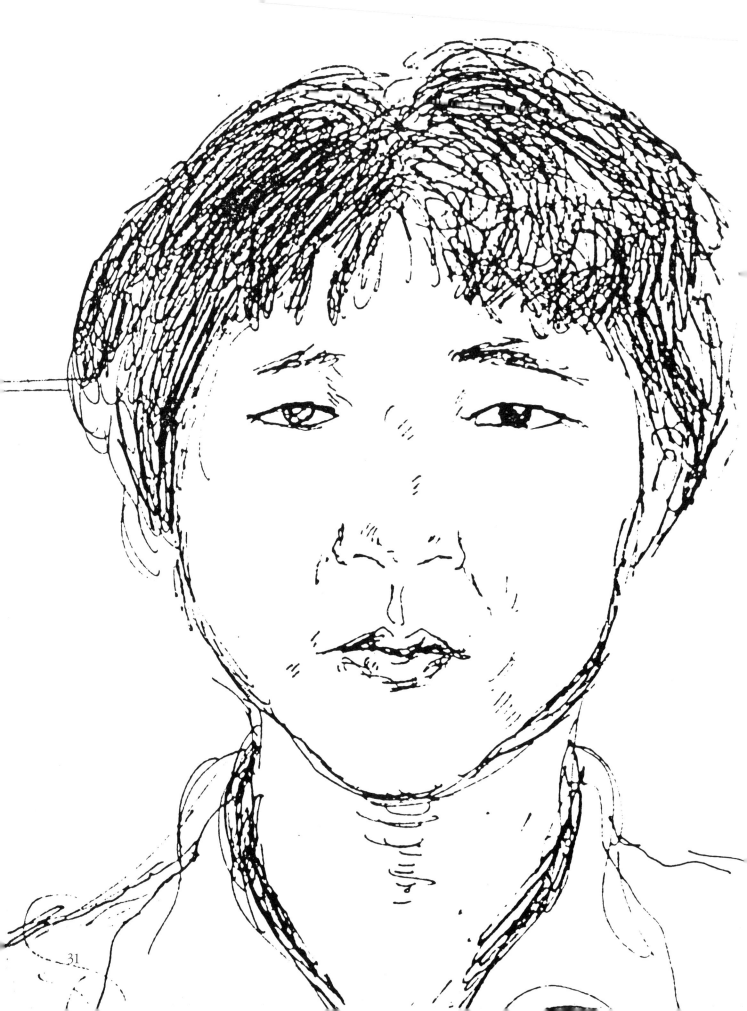

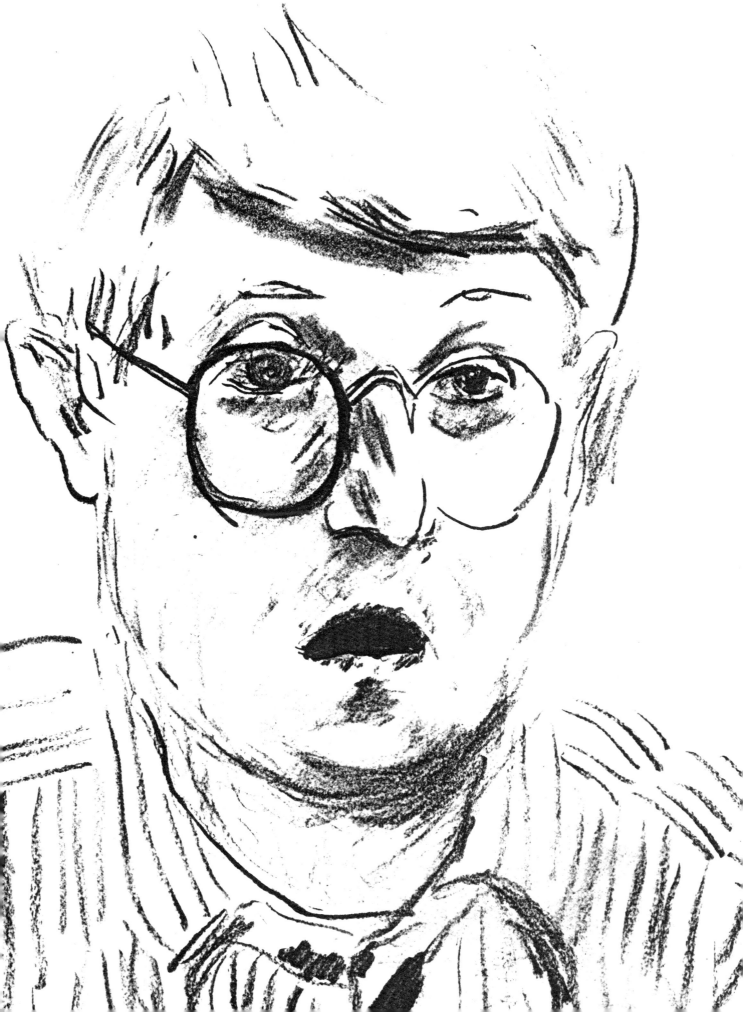

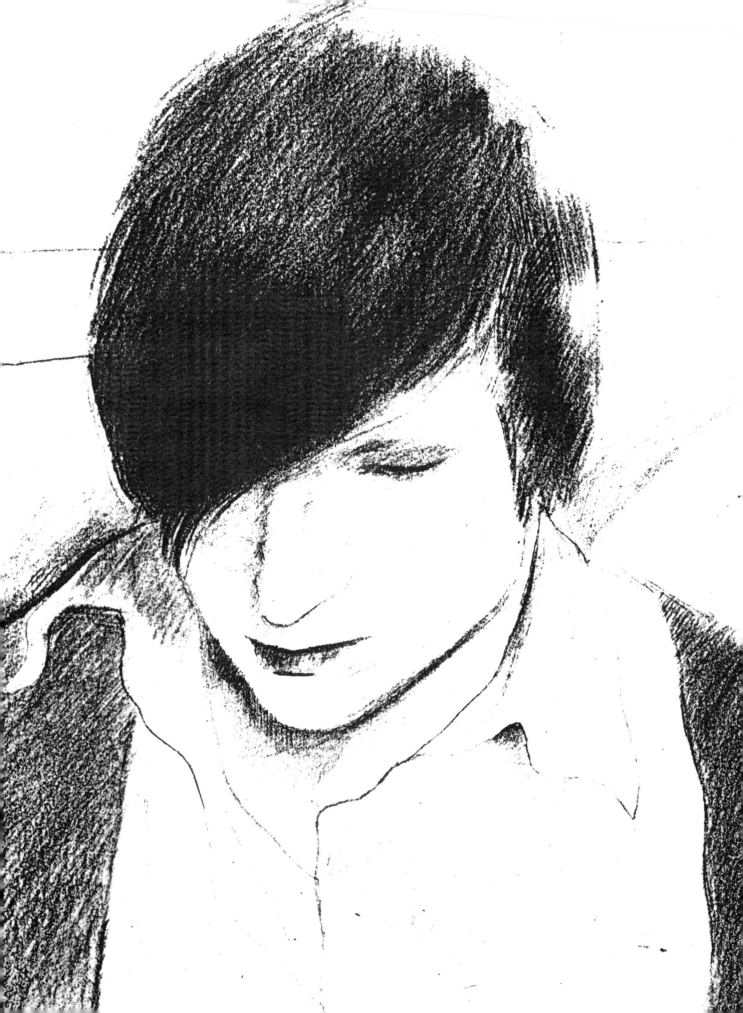

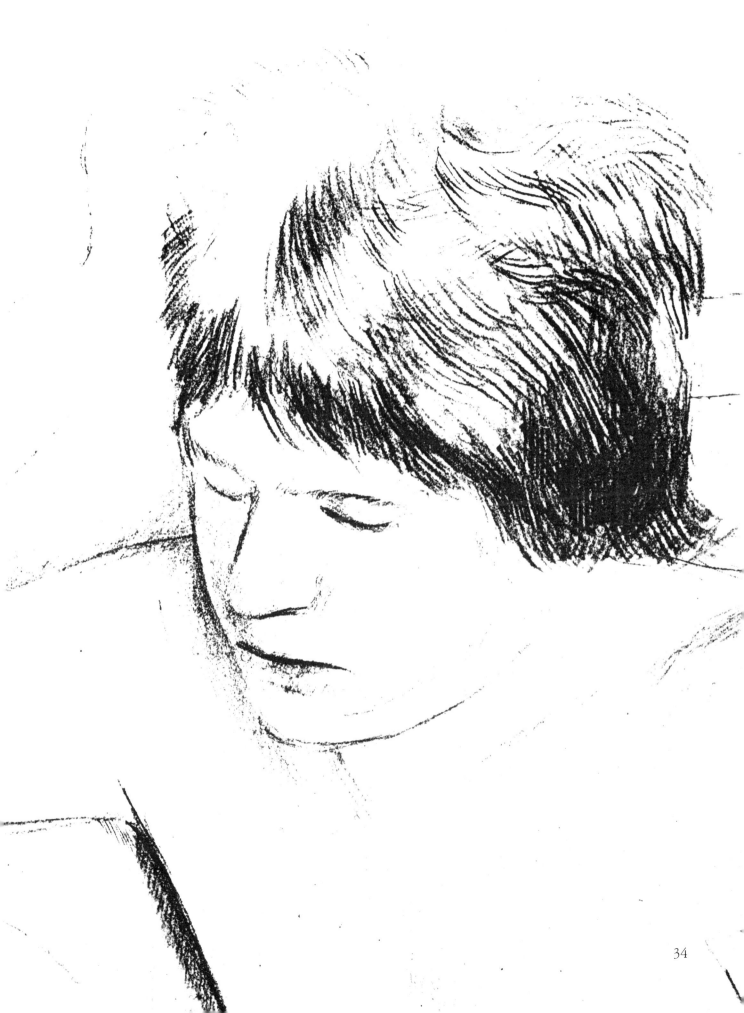

34

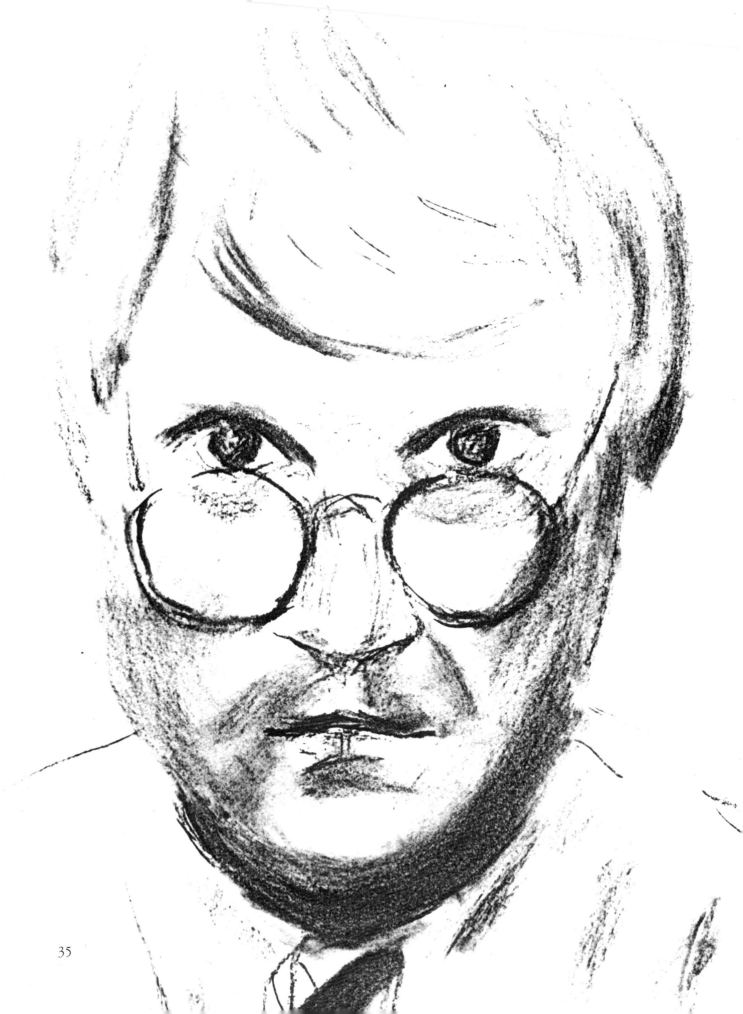

35

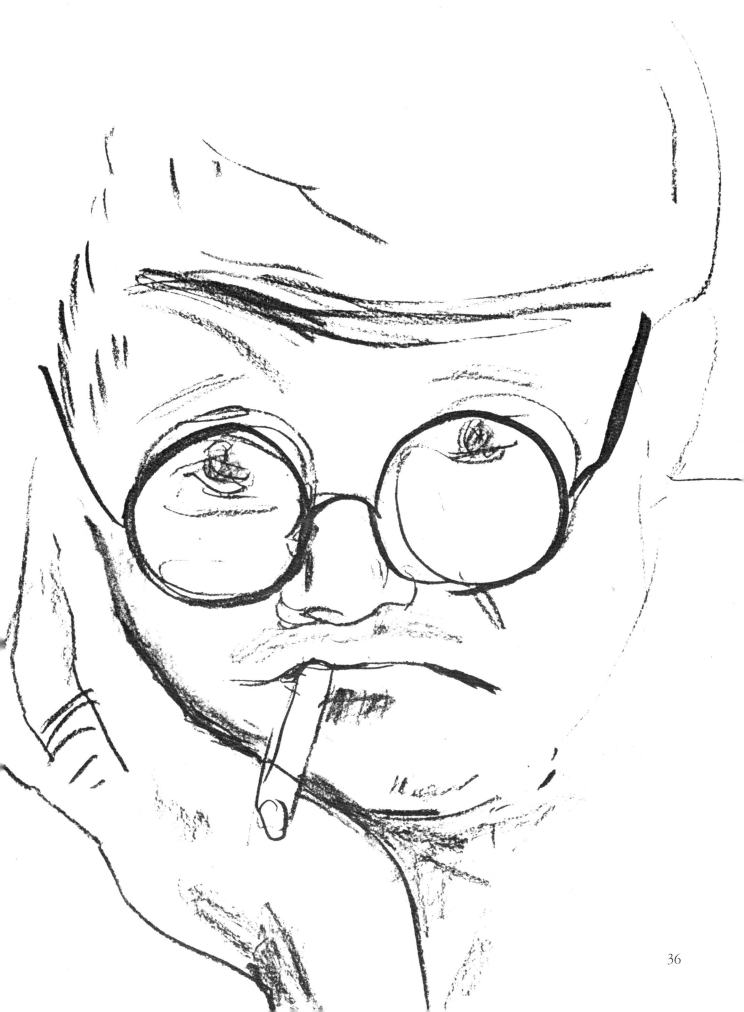

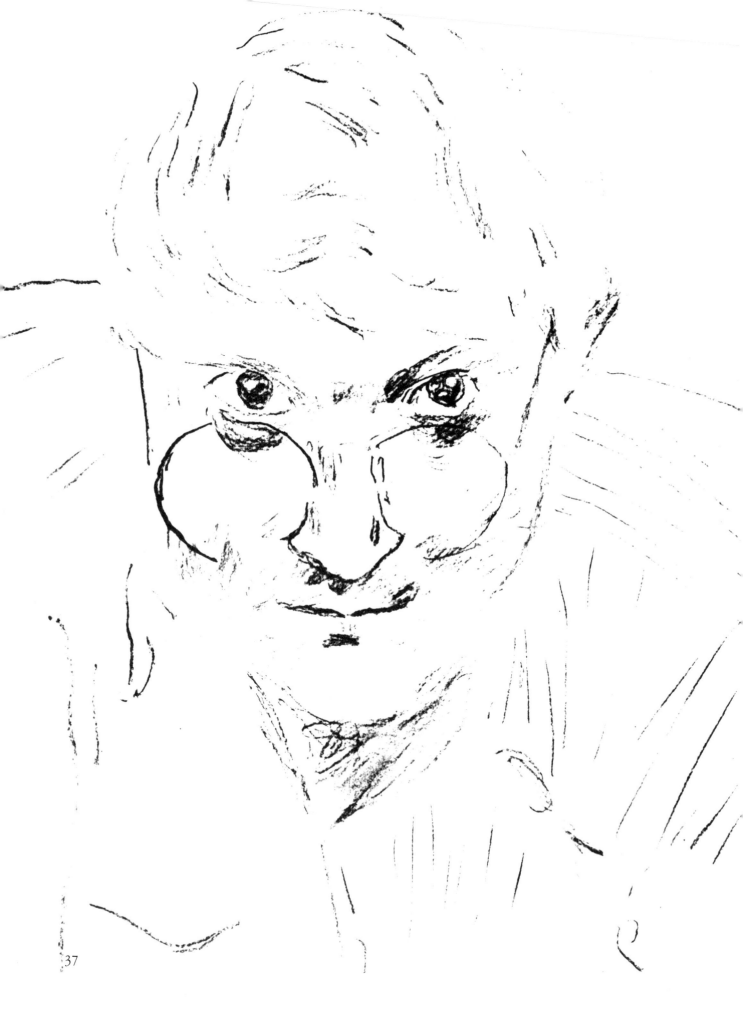

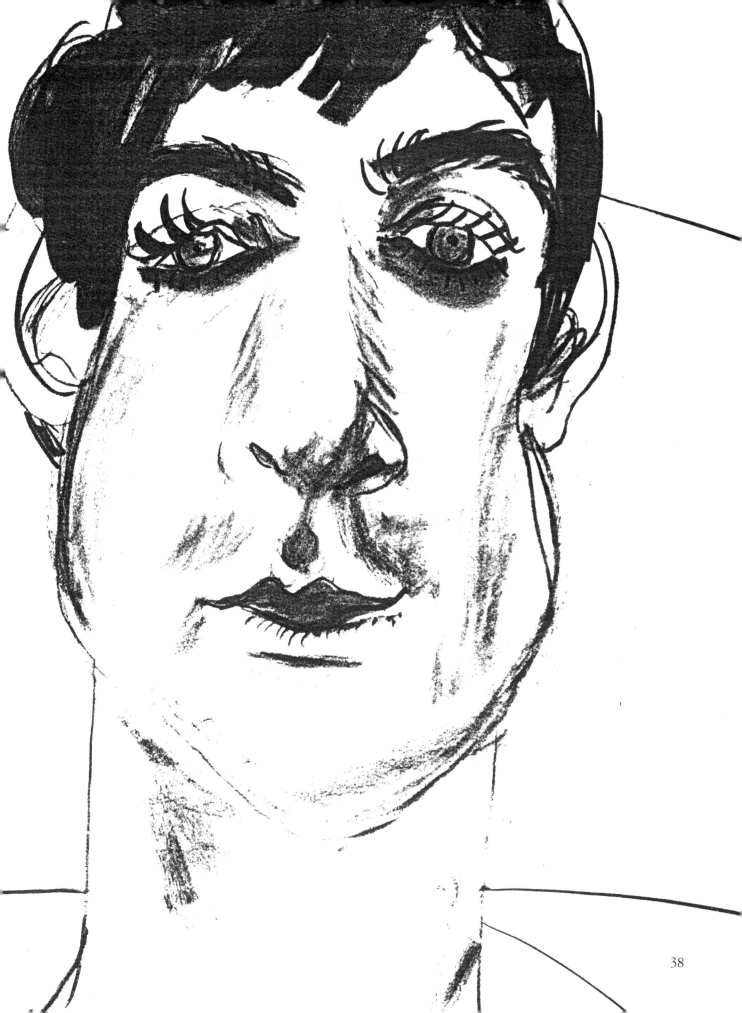

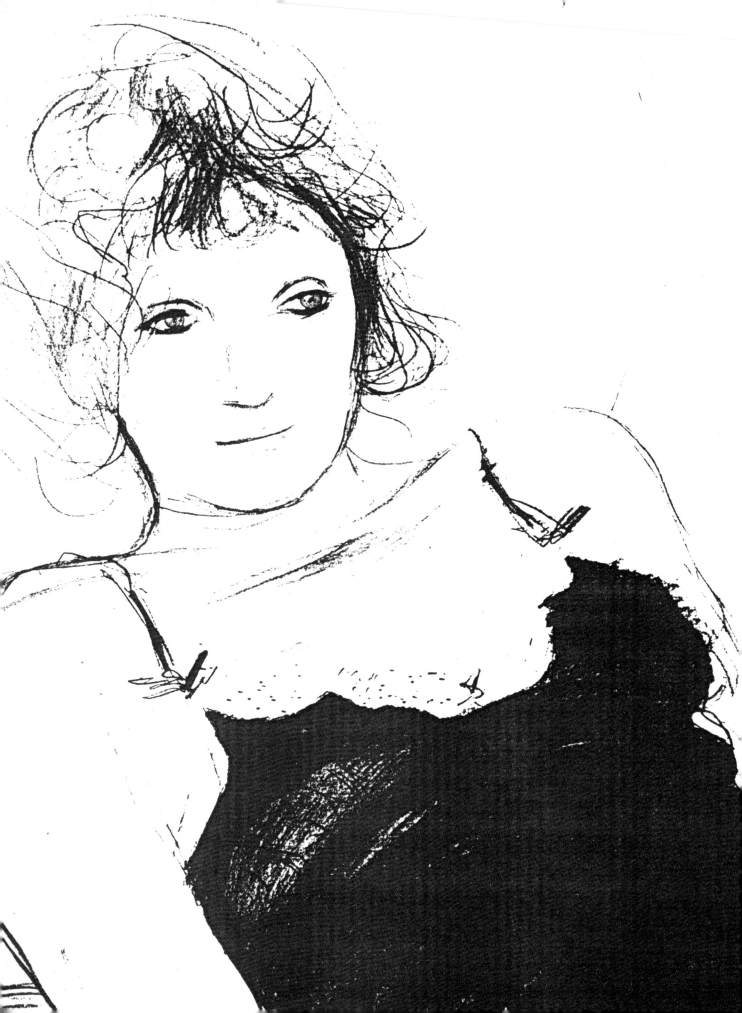

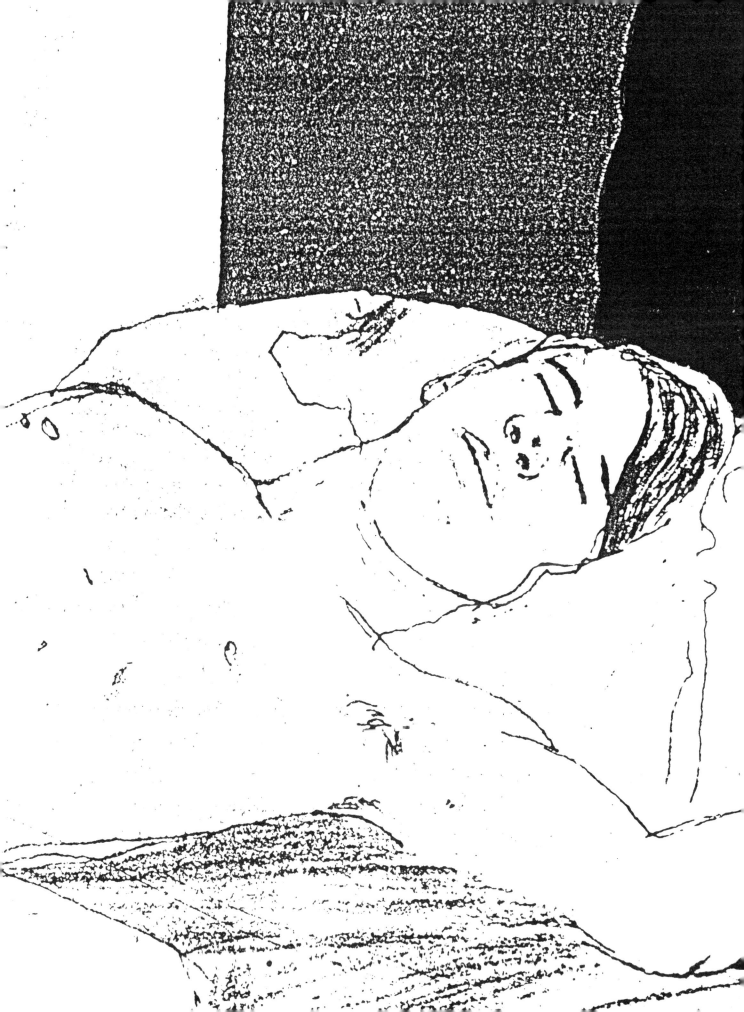

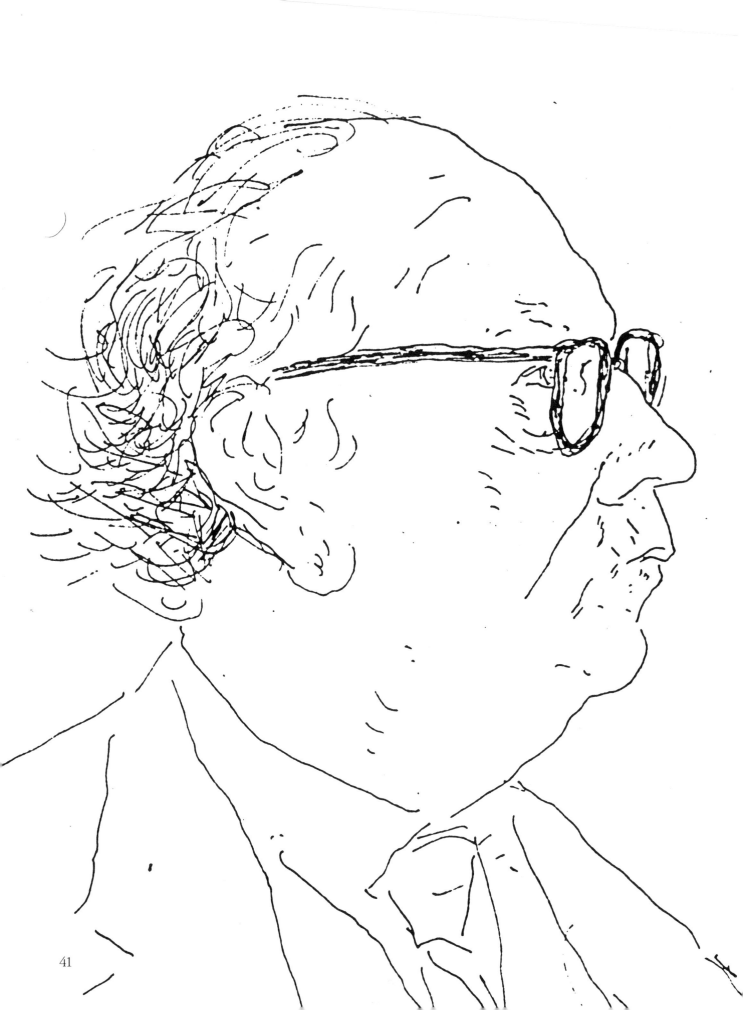

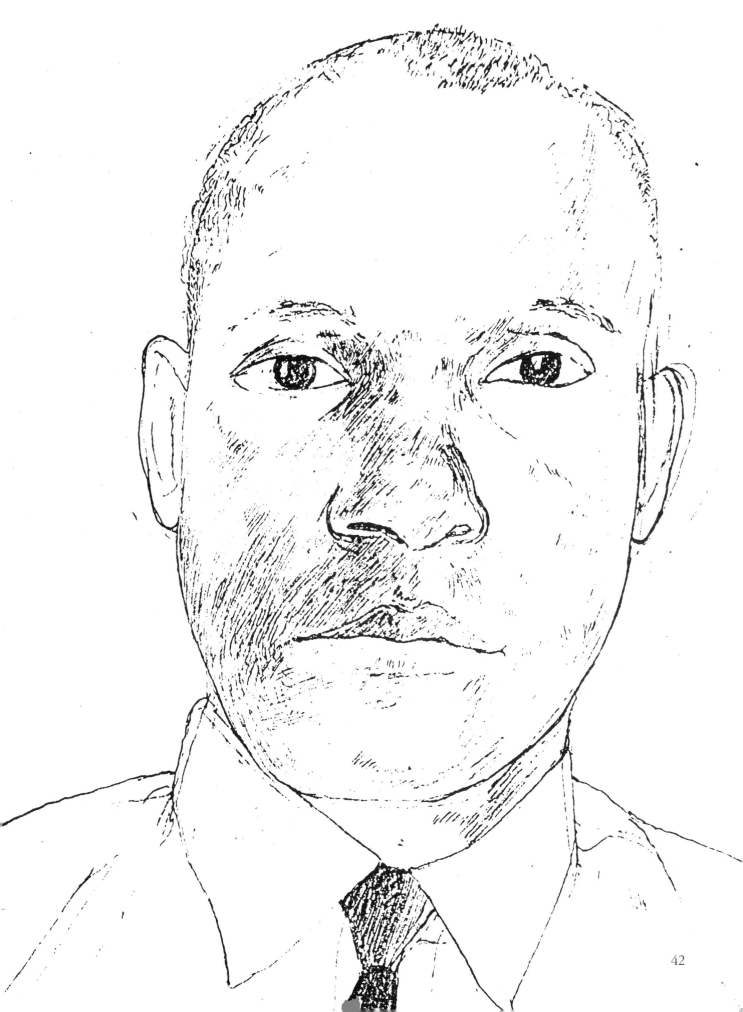

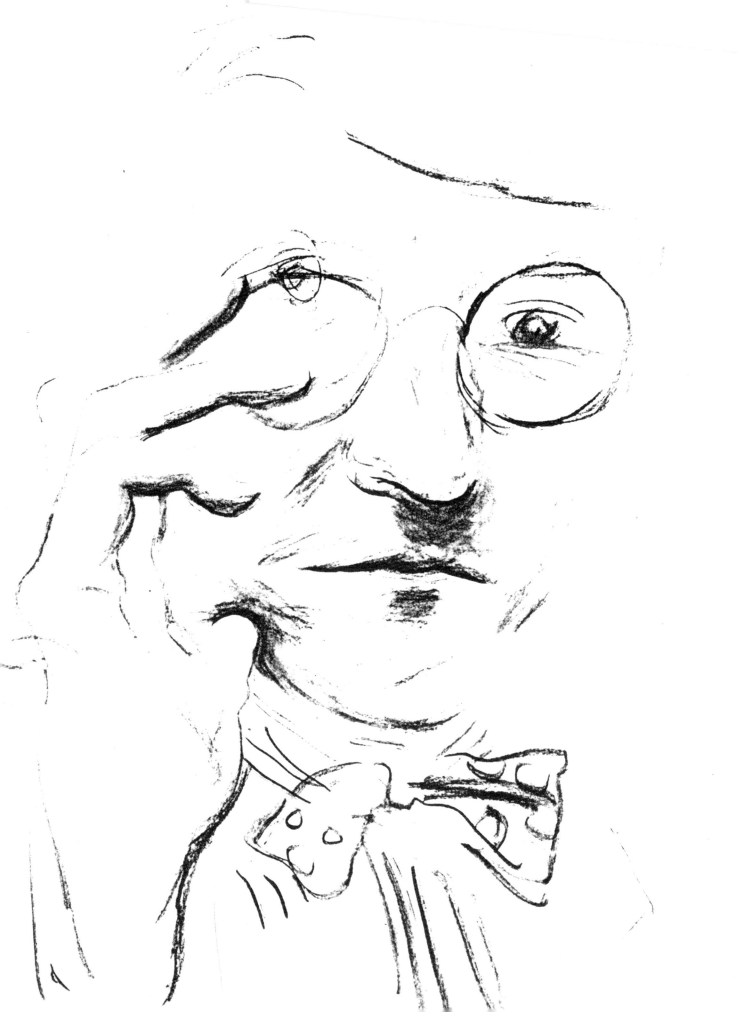

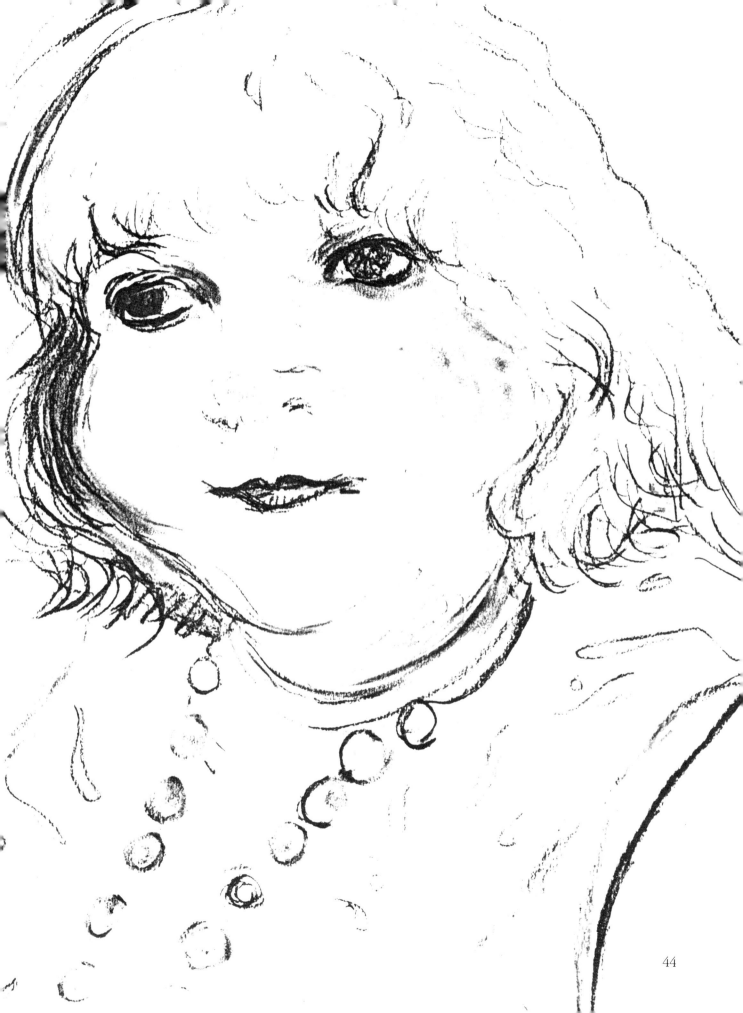

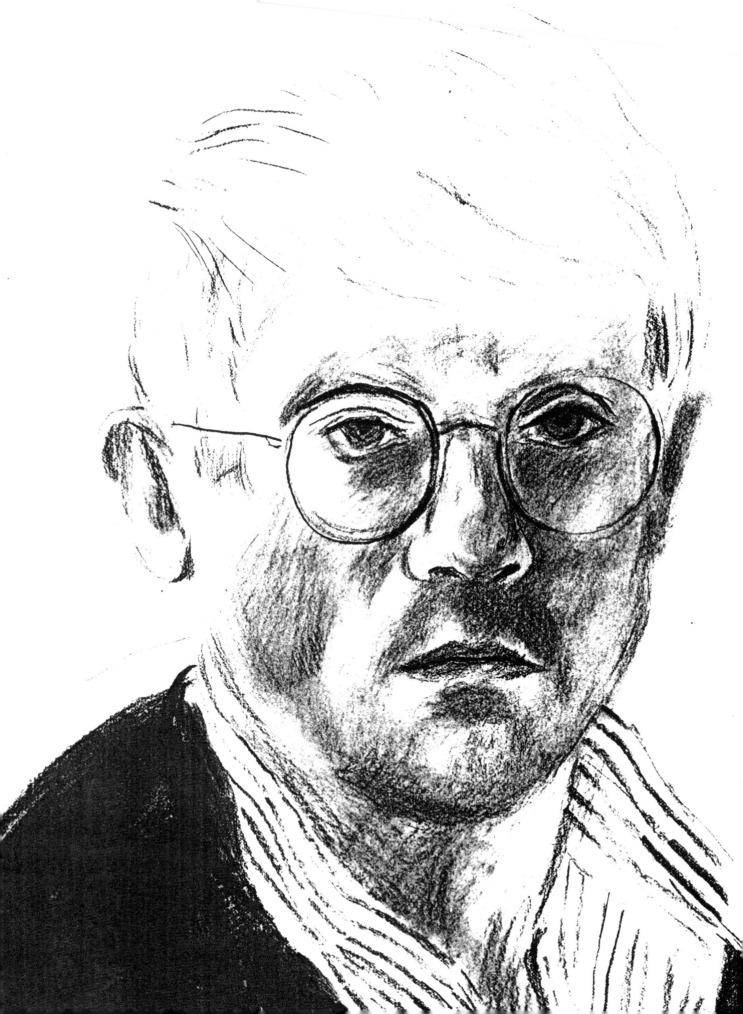

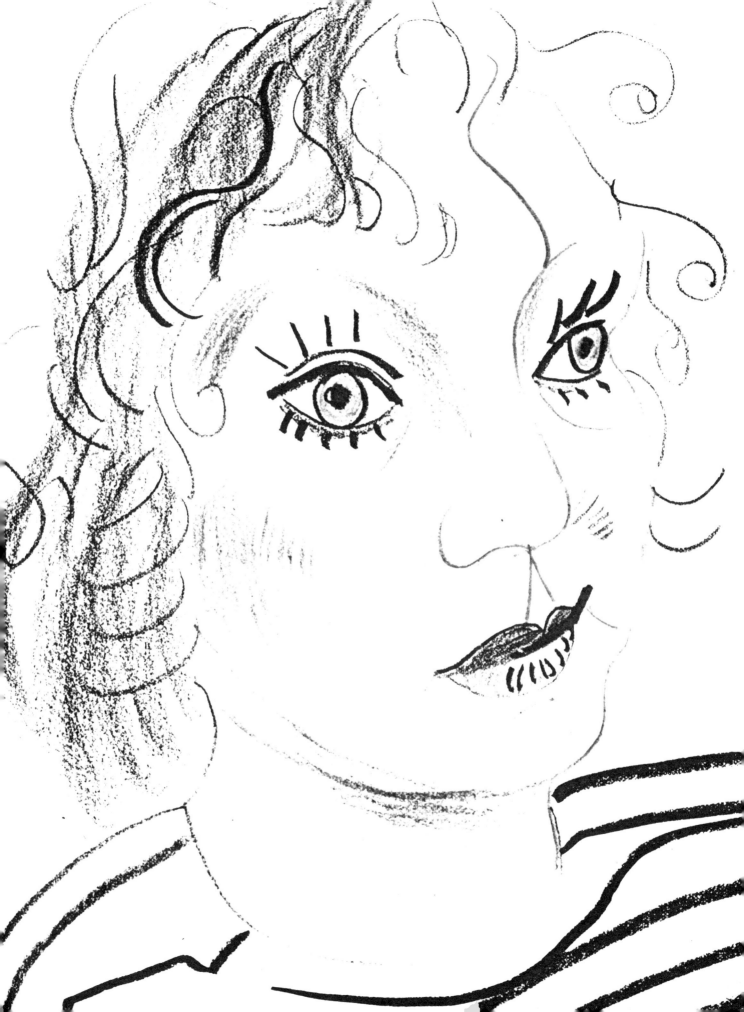

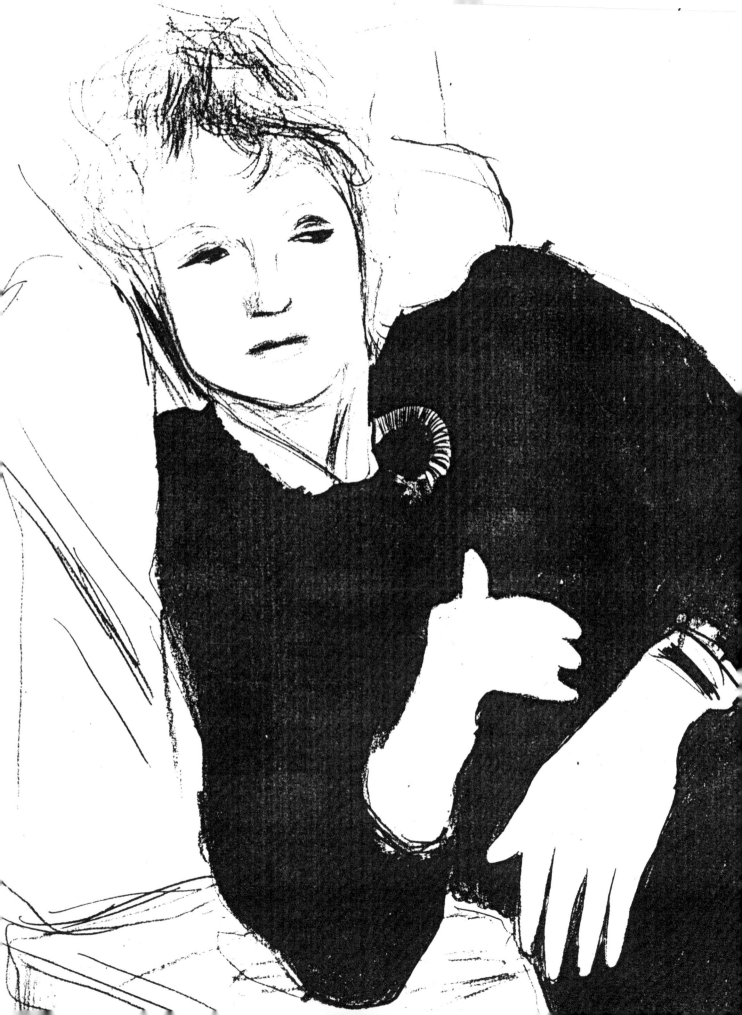

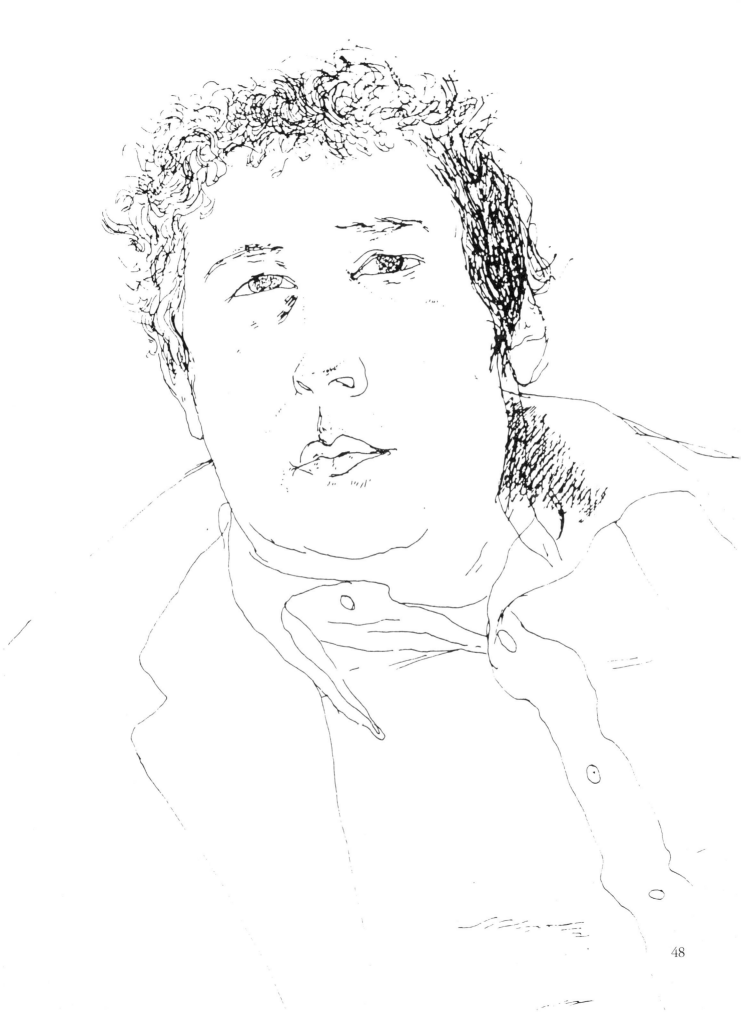

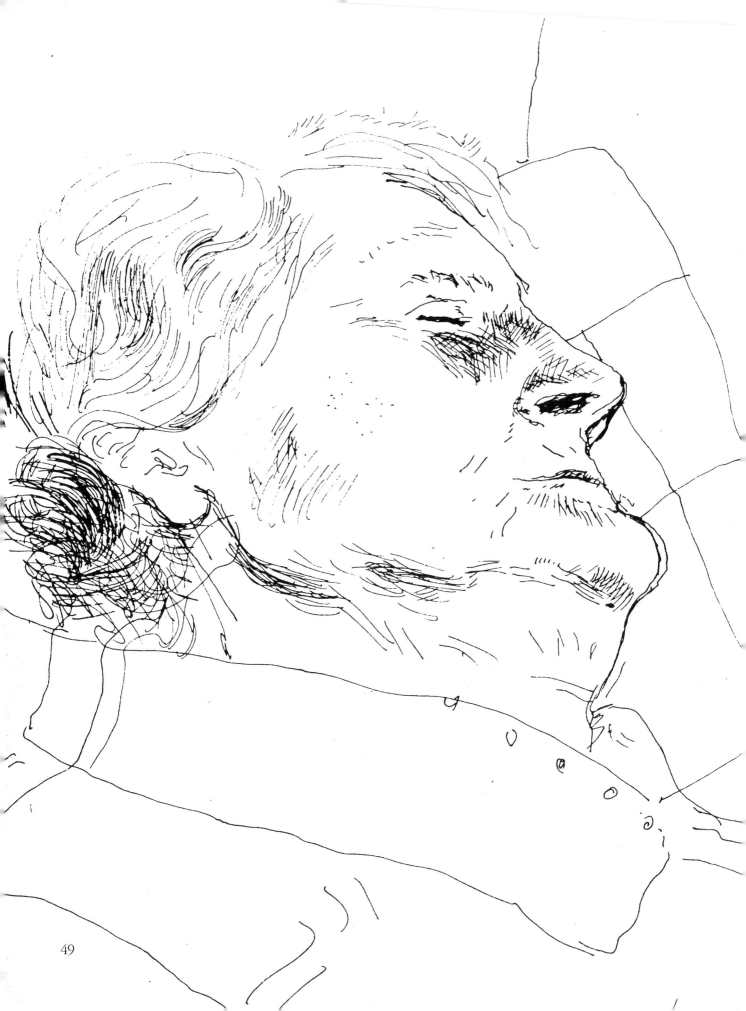

49

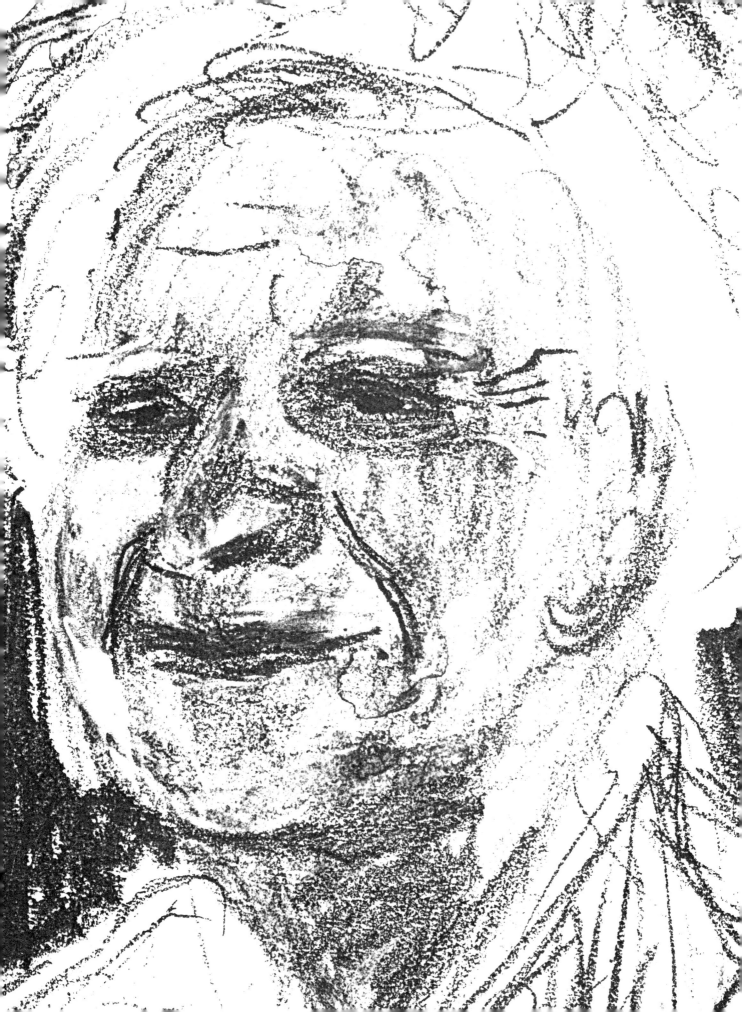

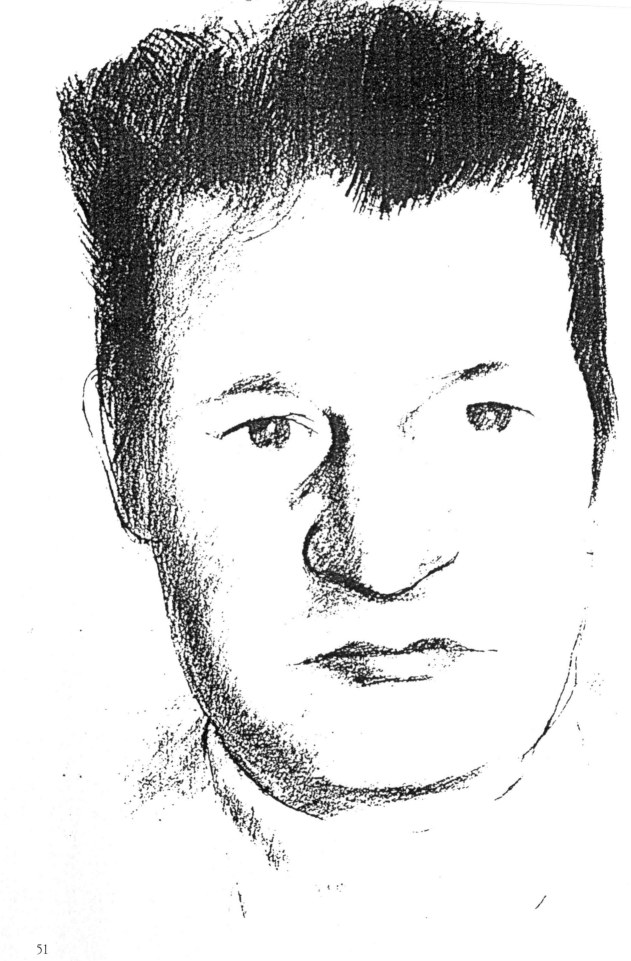

51

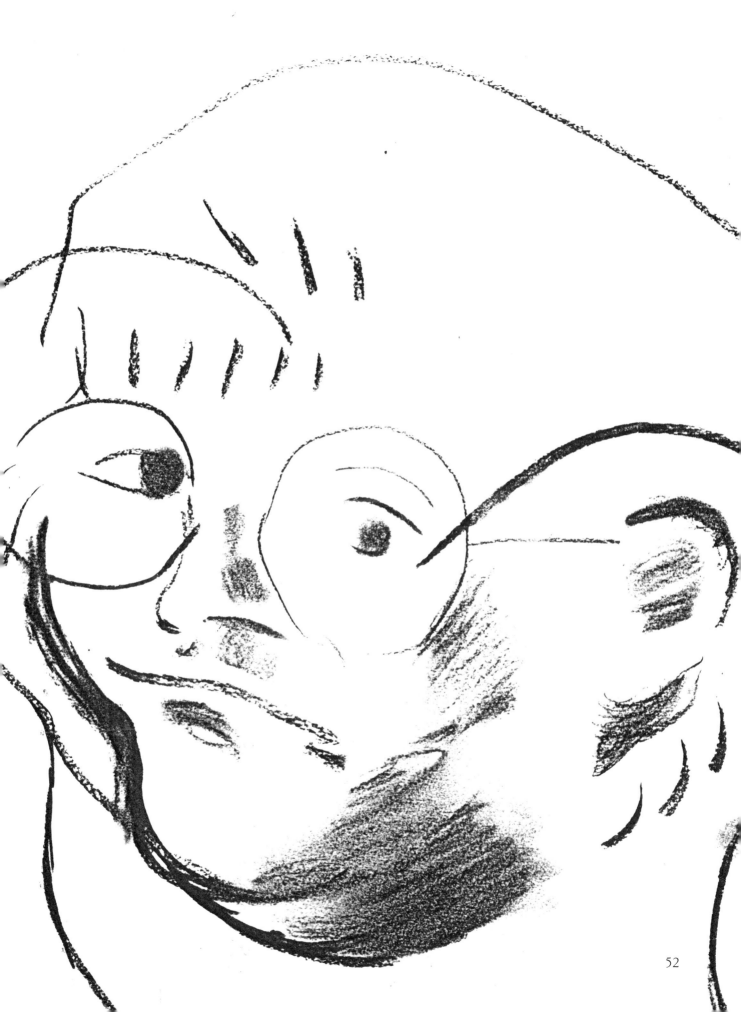

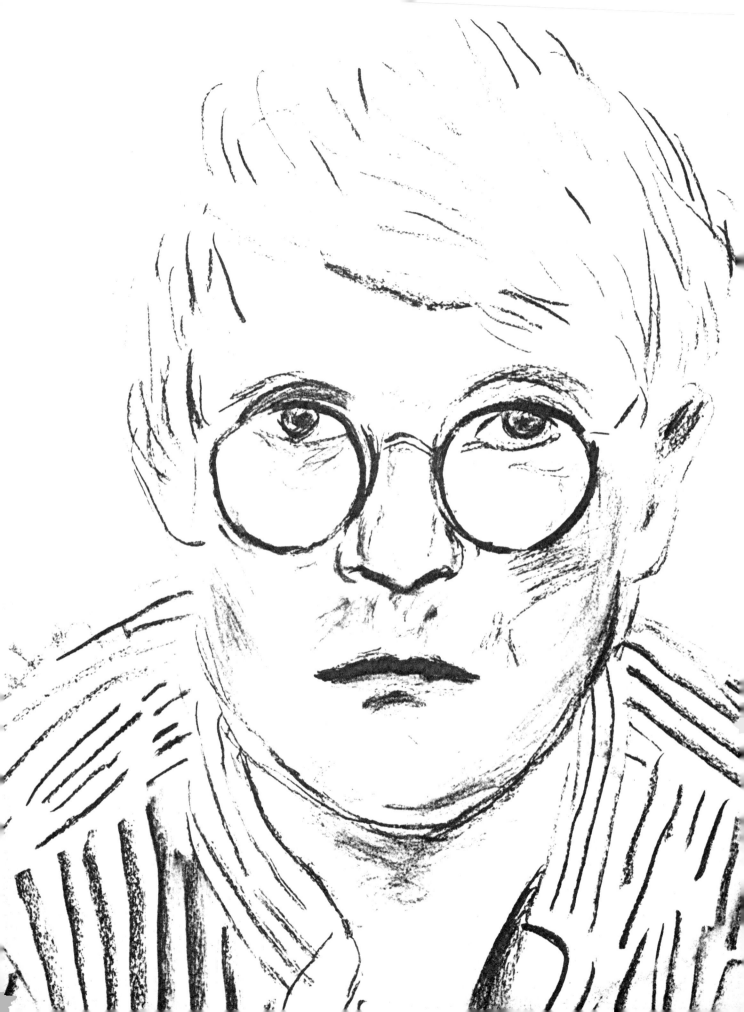

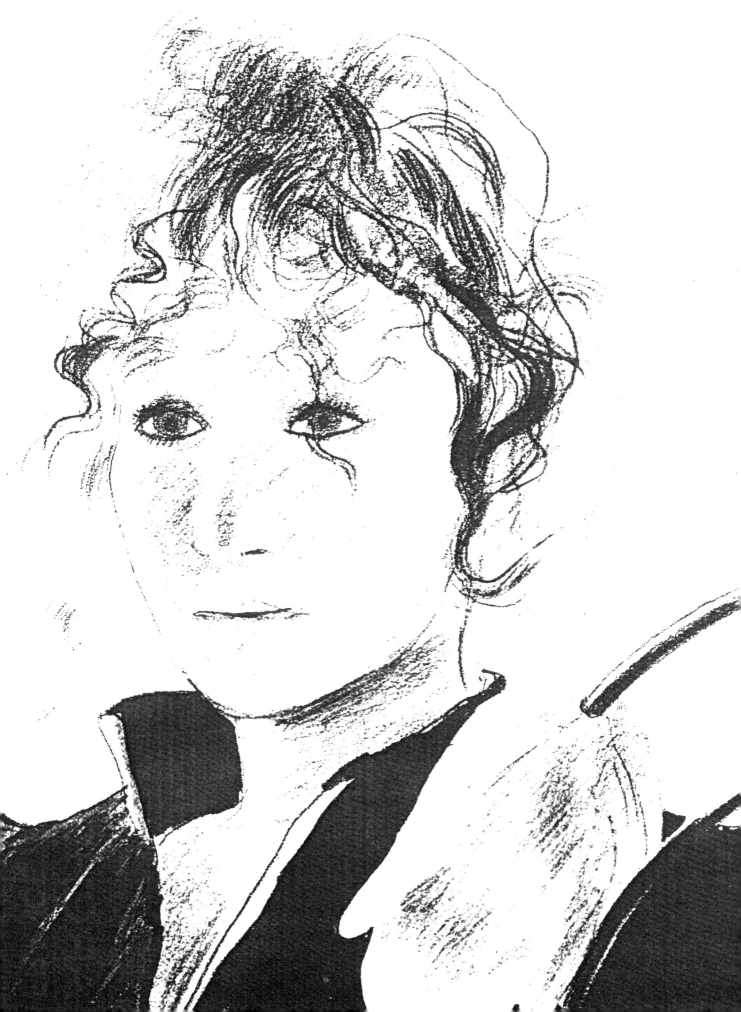

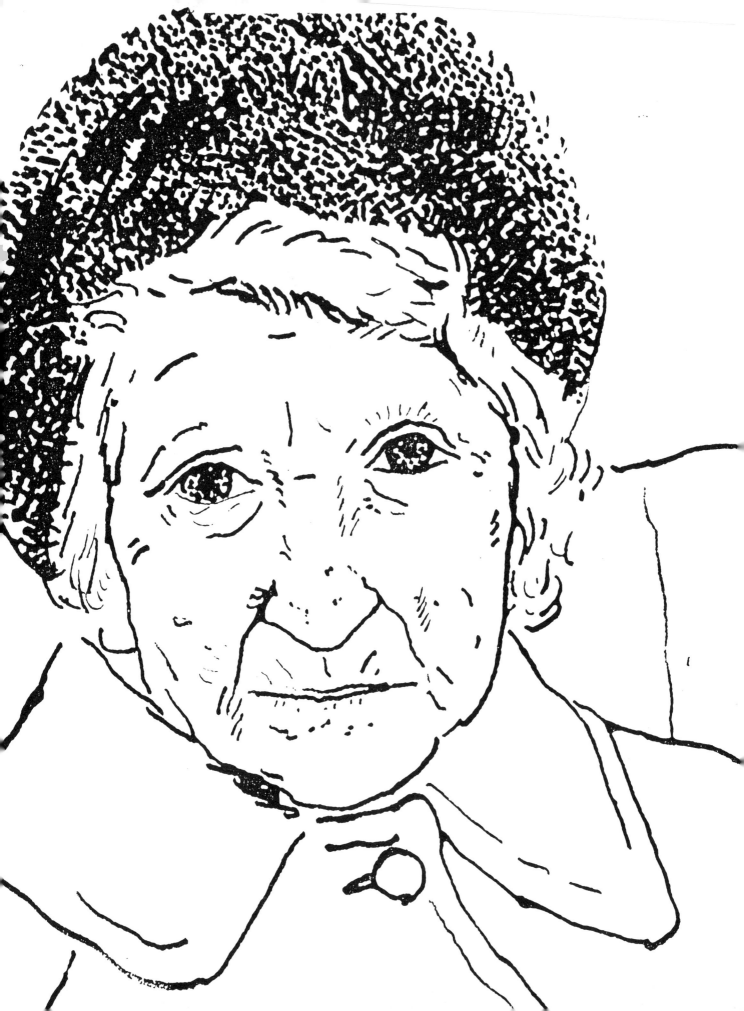

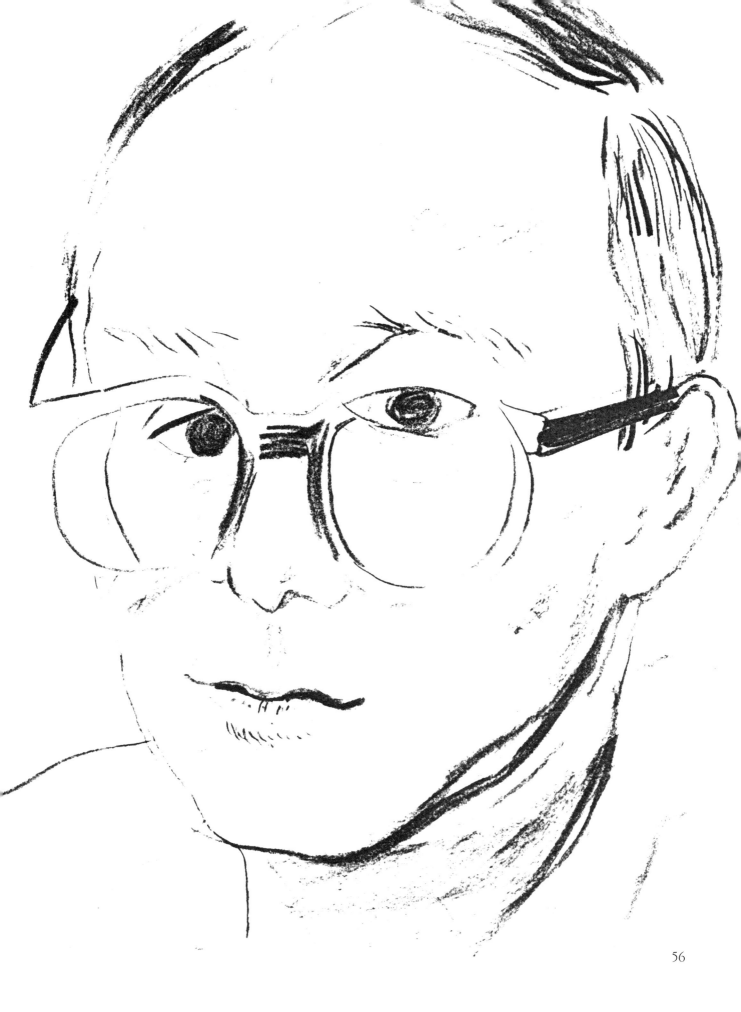

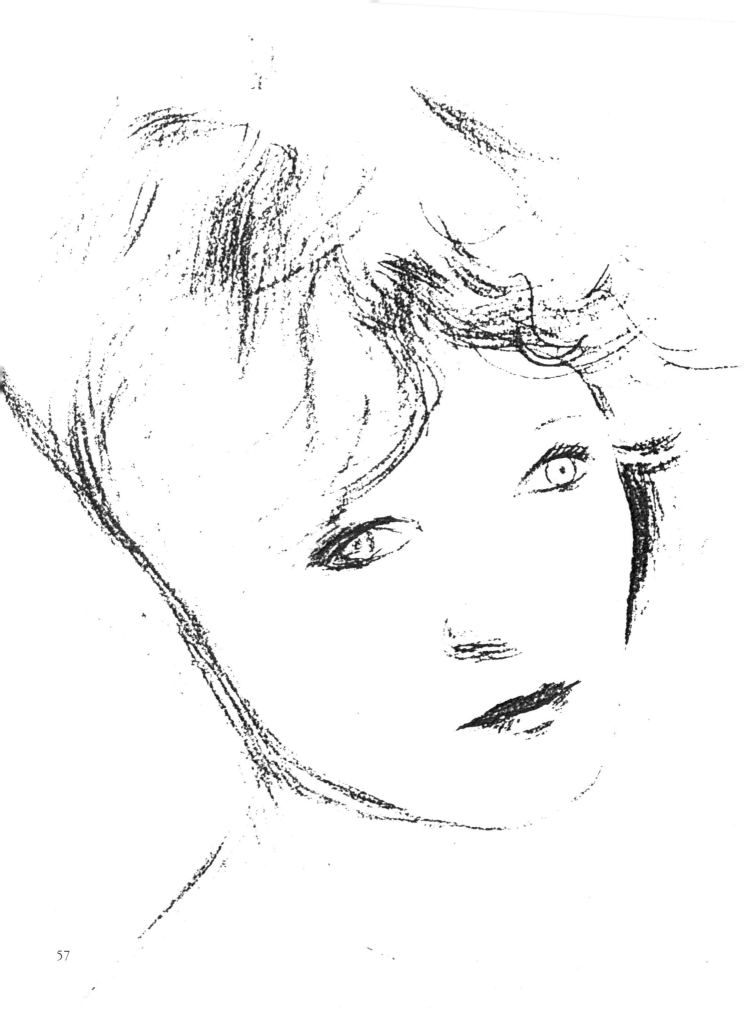

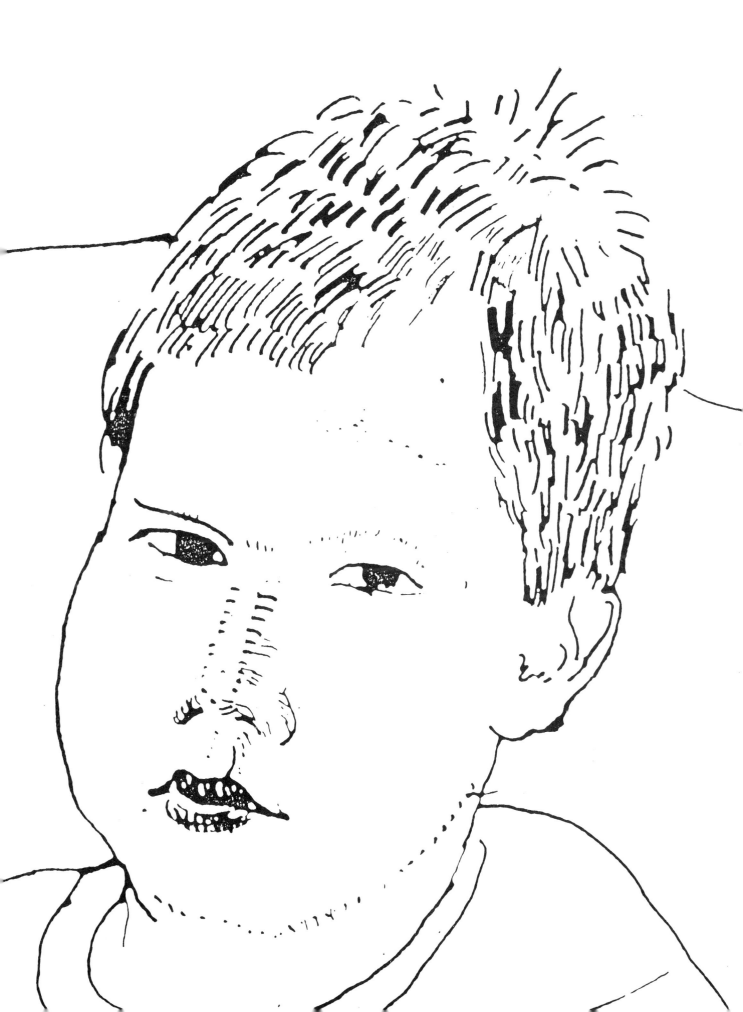

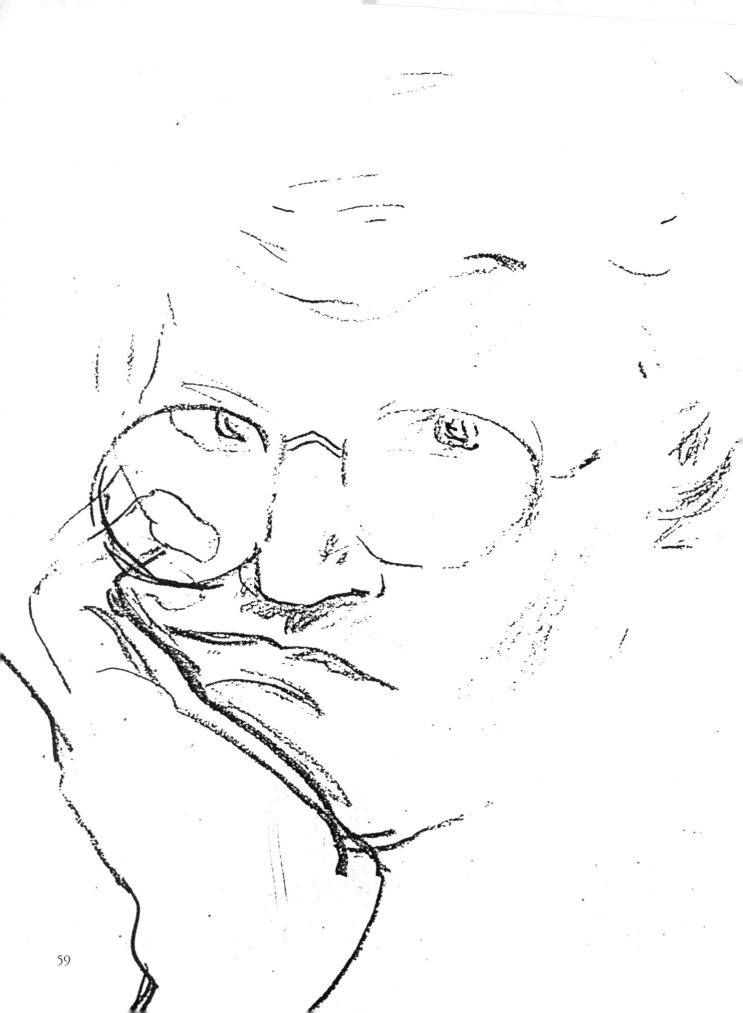

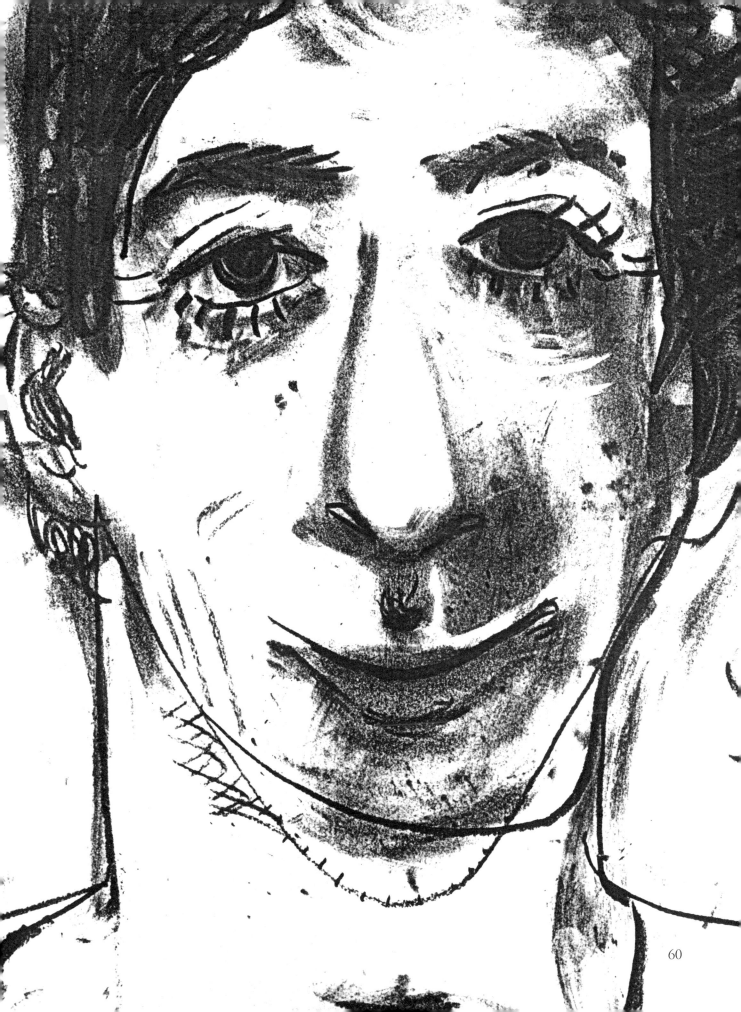

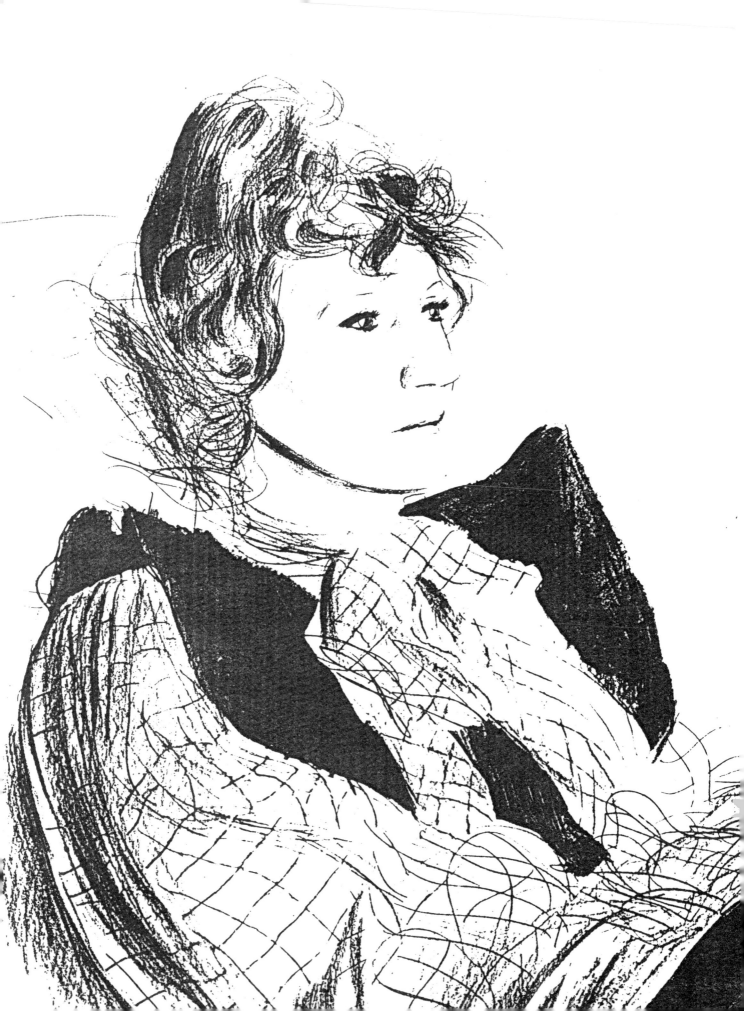

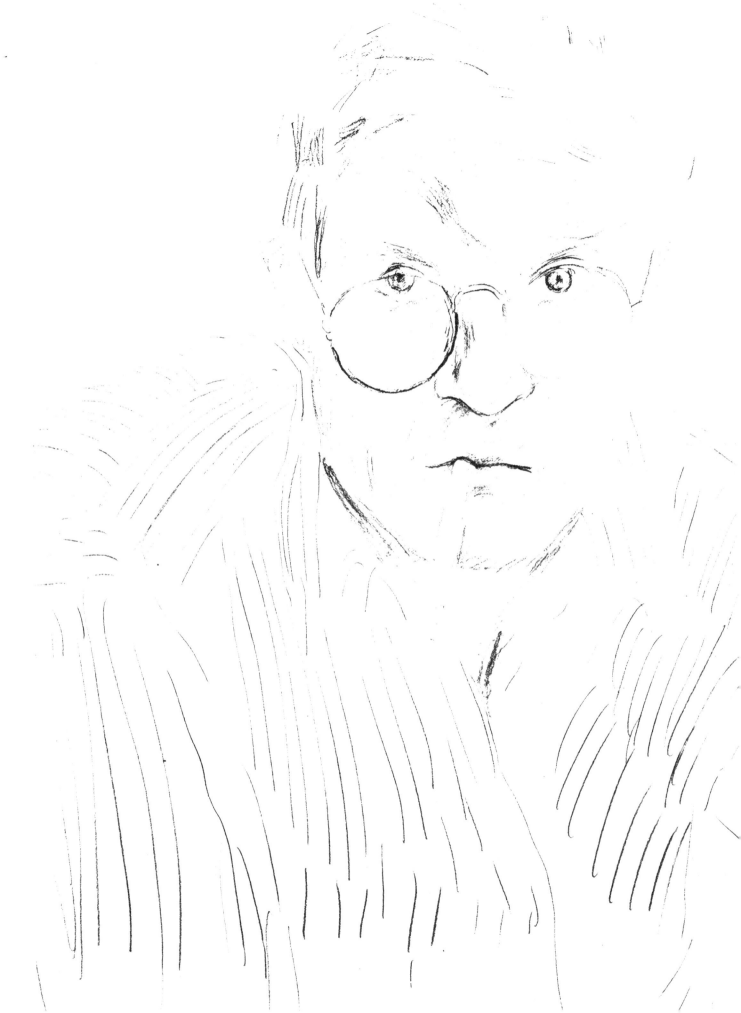

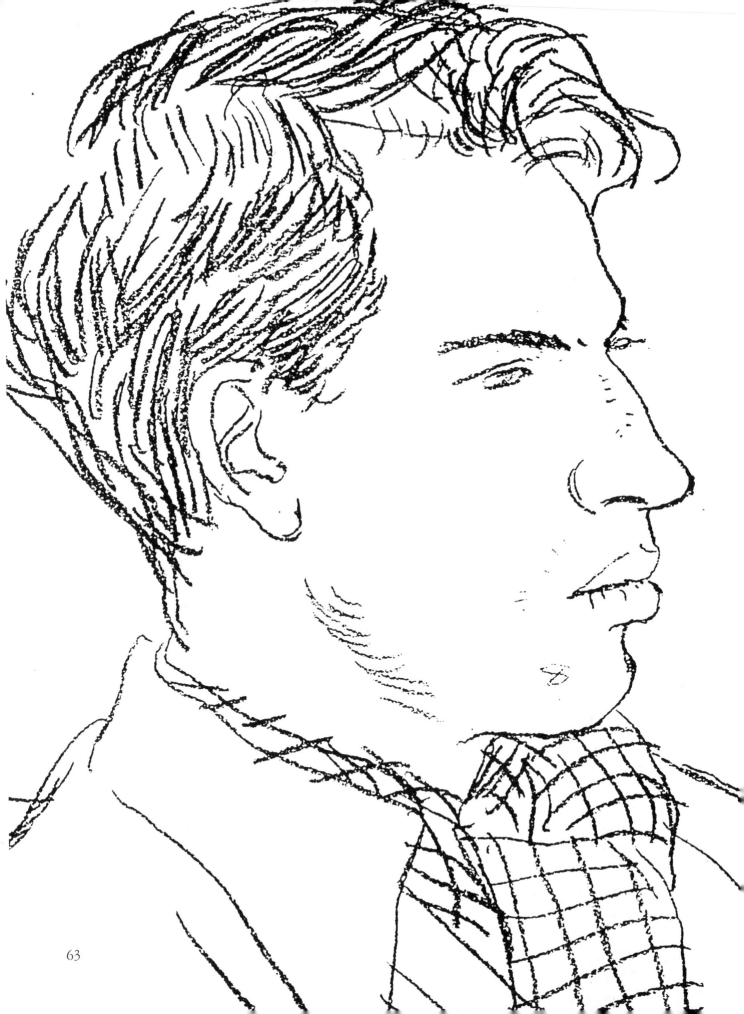

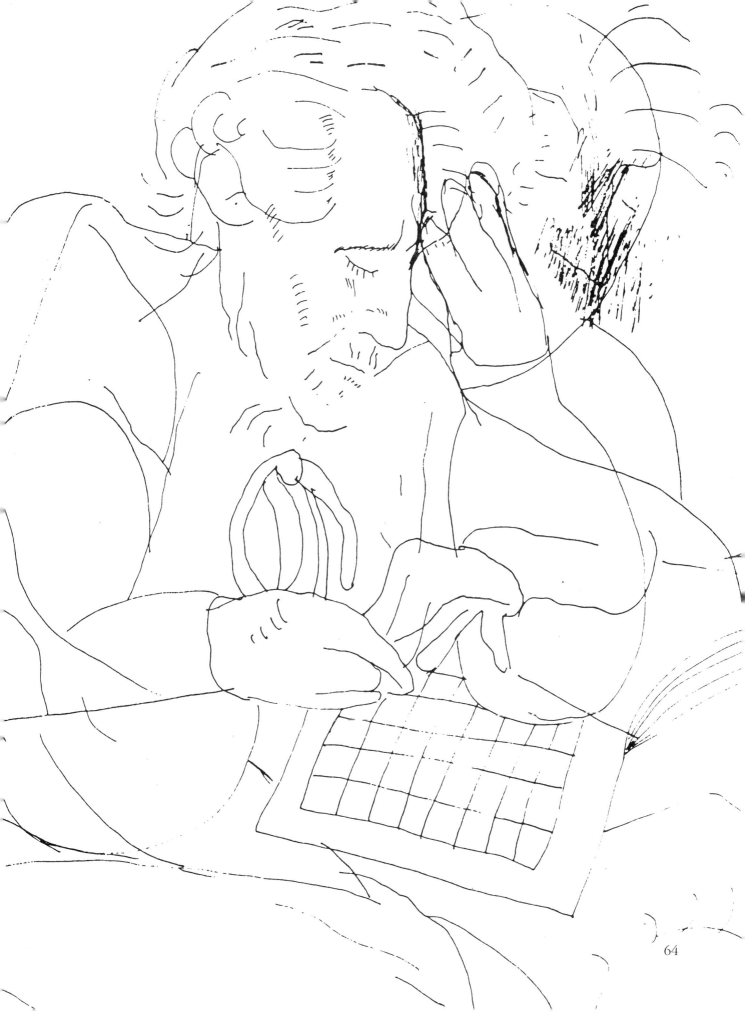

64

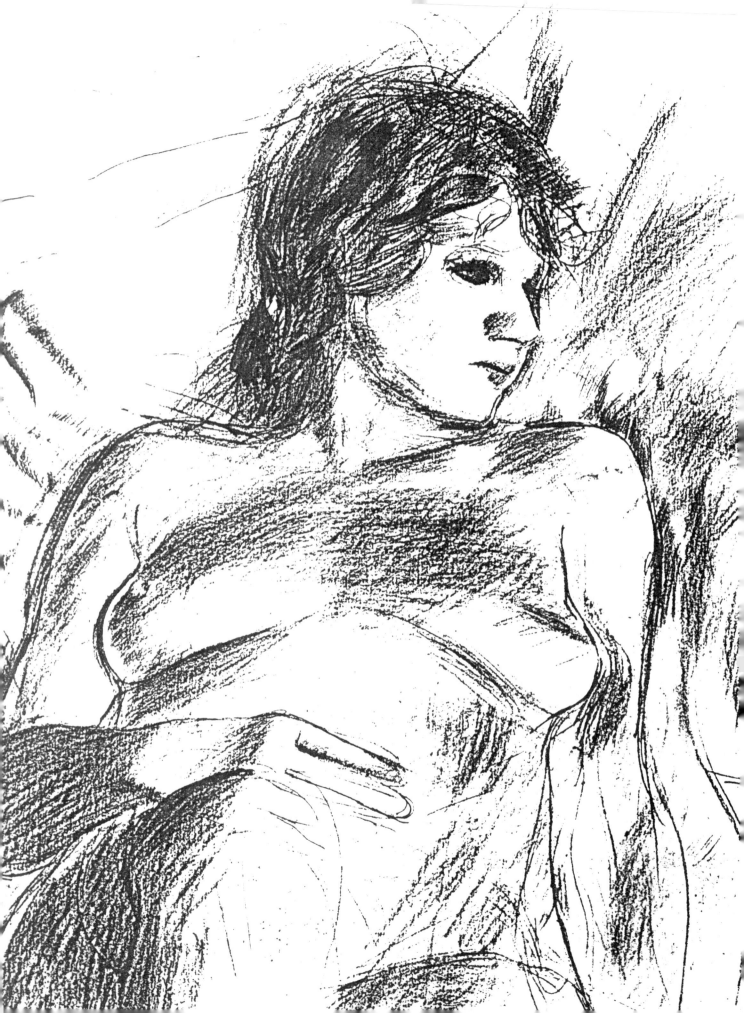

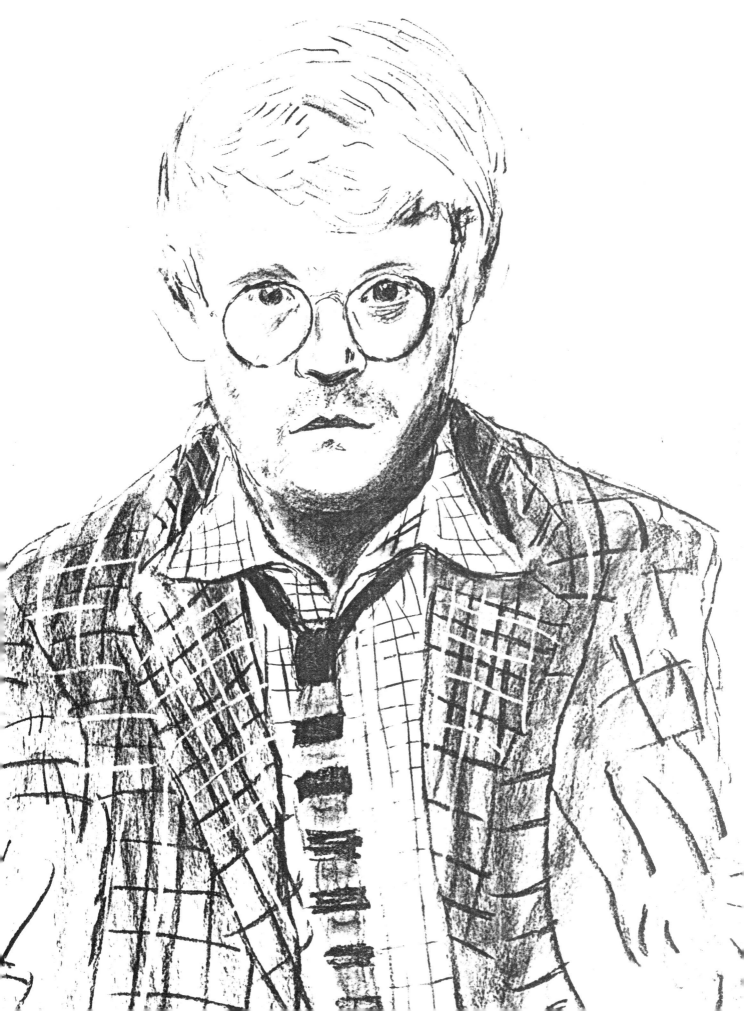

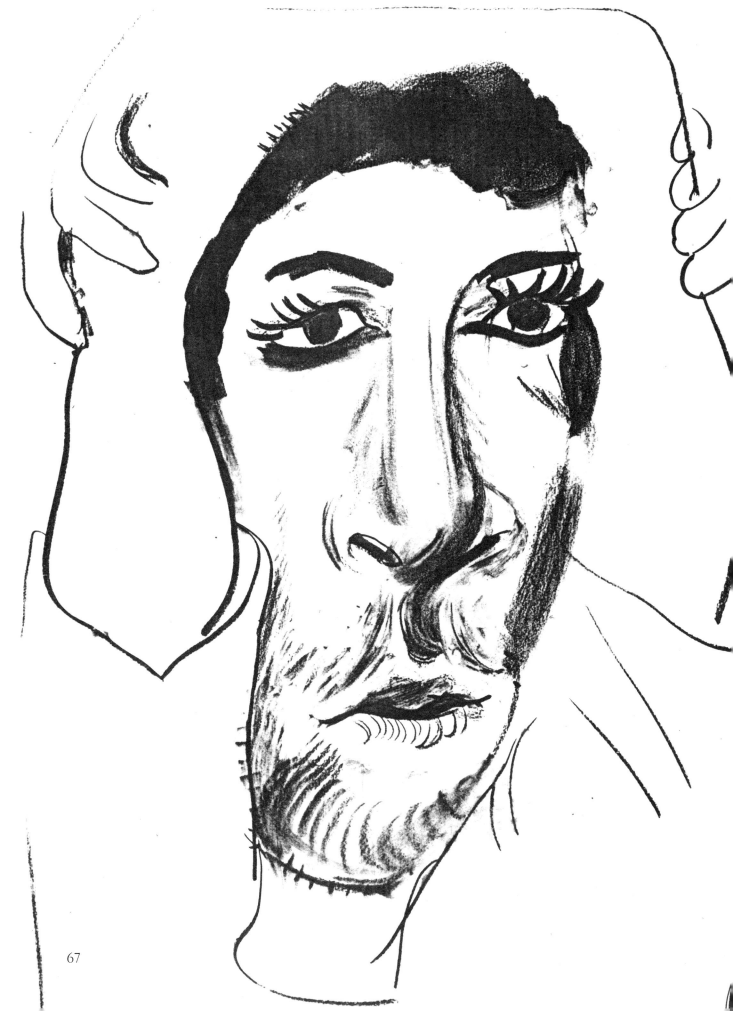

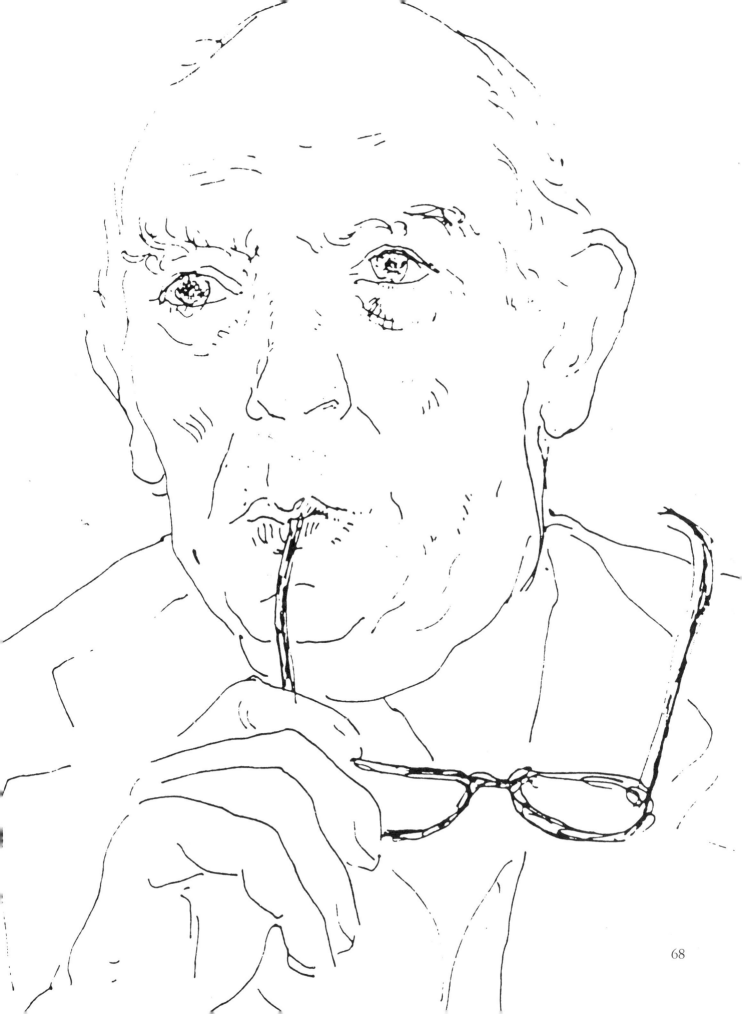

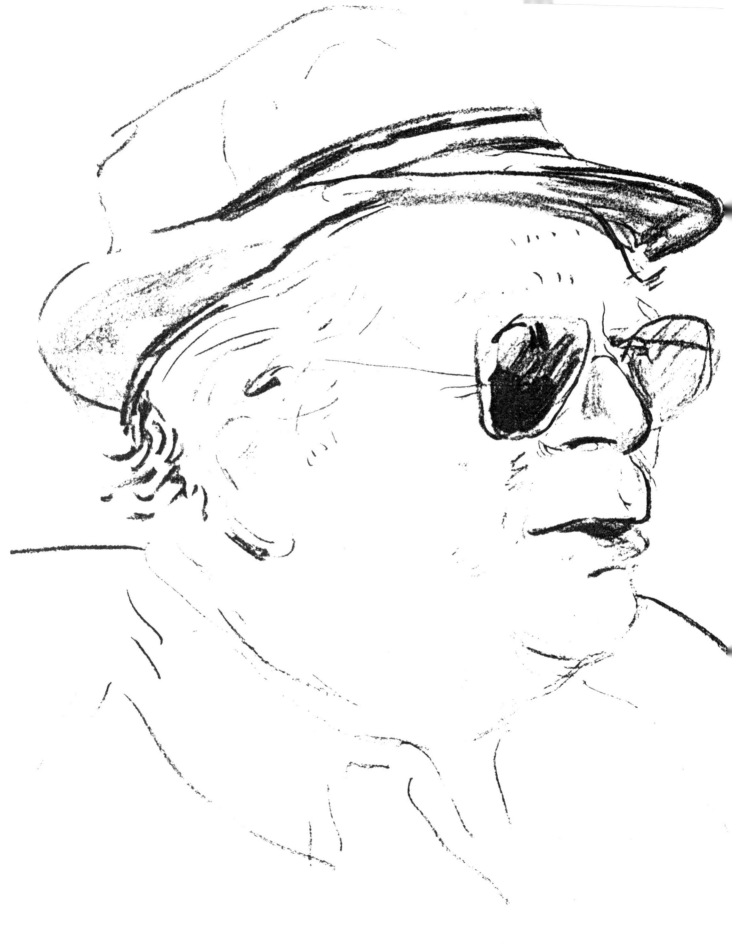

69

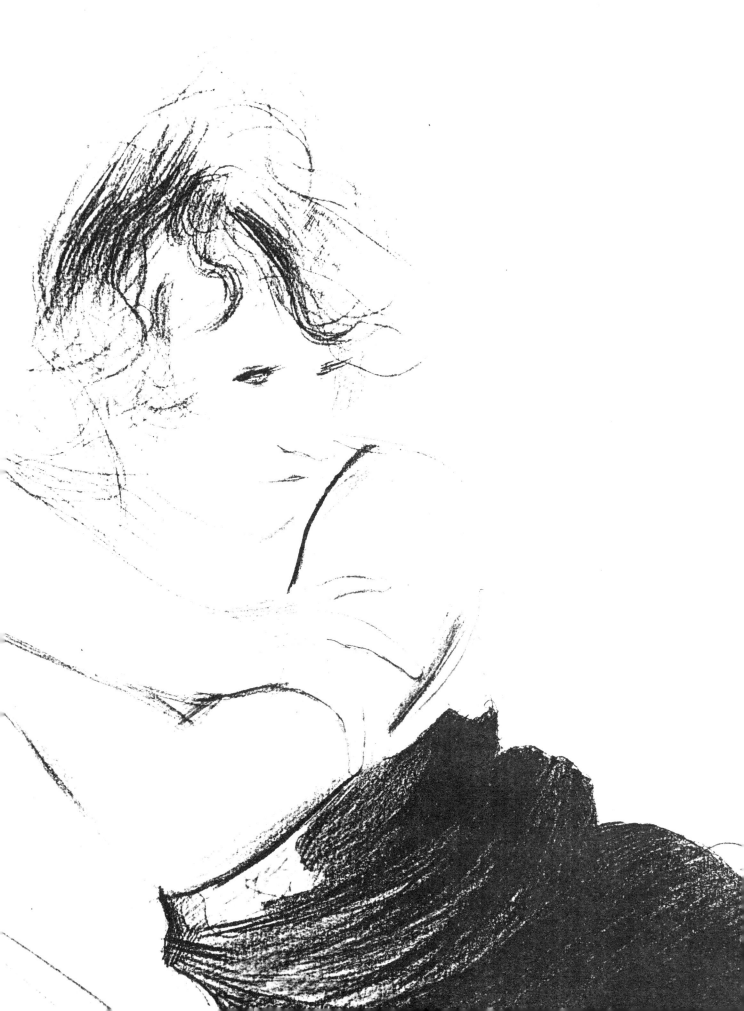

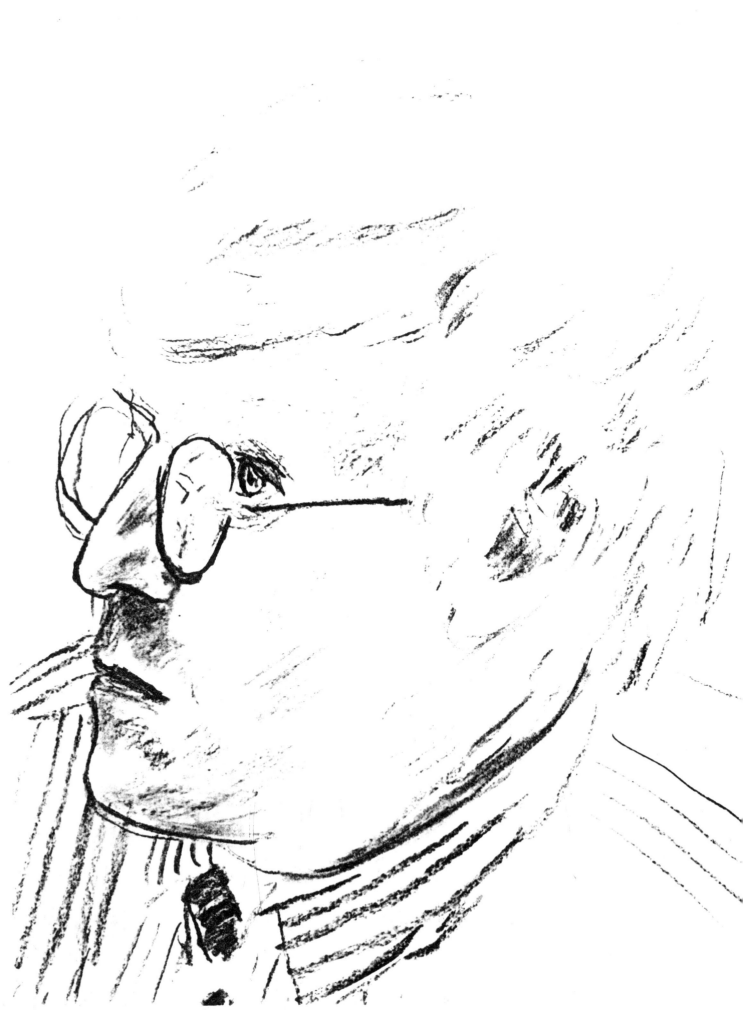

Illustrations

All illustrations are details from drawings whose full dimensions are given below. Height precedes width; all measurements are in inches.

Hockney's People: Notes to the Plates

by Marco Livingstone

Laura and Kenneth Hockney
(nos. 1, 2, 9, 11, 17, 18, 49, 55, 64)

When the misrepresentation of Hockney as a fun-loving sun-worshipper finally gives way to a more accurate assessment of his seriousness, it will be thanks in some measure to the moving portraits that he has made of his parents over many years. In the mid-1970s he produced some double portraits, both drawn and photographed, as studies towards a painting which he executed in two versions, the first completed in 1975 and the second (now in the Tate Gallery, London) two years later. His original plan was to incorporate a self-portrait in the mirror as a means of making explicit the theme of the painting as a study not only of his parents' relationship with each other but also of his emotional involvement with both of them. As is so often the case with Hockney's double portraits, much can be read into the separateness of the postures adopted by the two sitters. He later recalled that one of the things that most interested him in the subject was to make allusion to the ways in which people who have lived together for many years can communicate other than just by talking. In most of the studies and in both versions of the painting, his father sits patiently but with a distracted air, apparently lost in thought or, in the later painting, immersed in a book. His mother, on the other hand, faces the artist squarely and gives him her full attention.

In the individual portraits, too, it is the ones of Hockney's mother which seem psychologically more incisive. The 1972 ink drawing of the father, for instance, contains a wealth of observation, but these are primarily notations of purely visual phenomena — of, for instance, the spatial shifts produced when one looks through a pane of glass — or of the attributes with which the sitter invented for himself, such as his self-consciously dapper mode of dress or his eccentric habit of wearing more than one wrist-watch. In observing such habits of self-presentation, Hockney is, of course, telling us something about the character of the person. The impassive expression which Hockney's father holds in the two crayon drawings of 1974, however, gives his face a somewhat mask-like appearance that holds us at a distance.

Hockney's mother, by contrast, seems generally to have been a much more willing conspirator in the making of her portraits. Among the most moving are the drawings of 18th February, 1978, the day before his father's funeral, and of the day of the funeral service itself. In the earlier of the two drawings reproduced here, Hockney's mother seems to be staring into space, contemplating the emptiness that awaits her now that her partner of nearly fifty years has died. In the drawing done a day later, her gaze is directed at the artist, as if through the act of drawing itself they were able to share their pain with each other and to express without recourse to words their need for mutual comfort. More recent portraits show her coping well with life on her own. In the portrait of 27 June, 1983 she appears to be embraced, almost engulfed, by a comfortable old chair cross-hatched in the manner of Hockney's 1975 stage designs for Stravinsky's opera *The Rake's Progress*. In another drawing produced on this same visit to his native Bradford, *Mother with Crossword Puzzle*, she is depicted deep in concentration but also in a continuous flow of action. Her hands are a flurry of movement, one moment resting on her forehead, the next busily writing down the responses as they come to her. It is an affectionate and lively portrayal fitting of its subject.

Charles Alan 1969 (no. 3)

Hockney's first exhibitions in New York, held in 1964 and 1967, were held at Charles Alan's gallery. The sitter, who has since died, is described by the artist simply as "a very nice man, a charming man". Impassive in his stance, patient and unflinching in his return of the artist's gaze, Alan in this drawing gives away no more of himself than can be gathered from Hockney's straightforward description.

Ian in Wicker Chair I 1982 (no. 4)

Ian Falconer was in his early twenties and had not known Hockney long when this portrait was drawn. Himself an artist of considerable promise, he is shown here in an expectant mood, the patterns of broken lines suggesting a nervous energy that belies the apparent composure of his stance. The irregular hatchings by which Hockney defines the form of the chin, left cheek and forehead seem to operate here not so much as a stylistic device but as part of the process of getting to know the contours of his friend's face.

Stephen Spender 1981 (no. 5)
Stephen Seated, China 1981 (no. 50)
Guide, Sian, China 1981 (no. 31)
Mr. Lin in Armchair, China 1981 (no. 30)

In May 1981 Hockney made a three-week tour of mainland China, accompanied by his friends Gregory Evans and the poet Stephen Spender, at

the instigation of Nikos Stangos of Thames and Hudson. The idea was to gather together sufficient visual and written material — drawings and photographs by Hockney, paired with Spender's diaristic account of the journey — for it to be published as a book, *China Diary*, in the following year. The trip was not without its disappointments. Hockney found, for instance, that it was almost impossible to make as full a record as he would have wished in the form of drawings; each day was so eventful that he would have had to devise a more rapid technique to note down his observations, and often he would find himself giving away drawings almost as he did them. He therefore decided to rely more on the camera, and to produce some pictures from memory on his return to the West. Hockney's other complaint was that it was difficult to get to know the local people. As he explained in the epilogue to the book, "there were only about four or five Chinese people with whom we made any real contact, all guides." Mr. Lin Hua, the guide who took charge of them during the whole of their trip, was described in Spender's diary as "rotund, smiling with commanding intelligent features — so there was some affinity in his appearance to those photographs of Mao Tse-tung which one sees everywhere in China — as though we had a miniature Great Helmsman as our guide." In conversation with Spender the following January in Los Angeles, Hockney recalled: "With our change of mood, the first person we looked at differently each time was Mr. Lin. When we were convinced China was a police state, we saw Mr. Lin as a bit of a monster; when we'd forgotten about it, Mr. Lin was just the charming man that he appeared to us to be!"

Ann *April 1984 (2 drawings)* (nos. 6, 44)

Ann Upton has known Hockney since 1960, literally more than half a lifetime ago for both of them. As she succinctly points out, "I knew David with black hair." She was living a street away from him in the Earl's Court neighborhood with the painter Michael Upton, who was studying at the Royal Academy Schools. Six months later they moved, like Hockney, to the Notting Hill district. She did some modelling for Roger de Grey at the Royal College, but was not drawn by Hockney until shortly after he had ceased being a student there in 1962. She recalls that she knew little about his work at the time but was attracted by his personality. "He always had a very funny way of looking at things which appealed to me. I came to London when I was about 16 — I more or less ran away from home — and we had something in common. We were both vegetarians, and we lived near each other and got very pally."

Celia Birtwell (nos. 10, 15, 39, 46, 47, 54, 57, 61, 65, 70)

Hockney first met fabric designer Celia Birtwell in about 1965 but got to know her better only on his return to London from California in the late 1960s, partly as a result of her growing friendship with Peter Schlesinger. In 1969 she married fashion designer Ossie Clark, whom the artist had known since 1961, staying with him through a rather tempestuous relationship until the mid 1970s.

One of the most remarkable aspects of Hockney's drawings of Celia is the way in which they acknowledge her sensuality without being sexual in their outlook. In the artist's view the sensuality of the drawings, particularly of the ones done of her wearing a négligée or slip in Paris in November and December 1973, was very much a reflection of her personality rather than just of his feelings towards her. "After all, she's a very feminine woman, not a masculine woman, and a very sweet-natured, gentle person."

Christopher Isherwood I *1984* (no. 7)

Christopher Isherwood and Don Bachardy, a portrait painter and Isherwood's companion since 1953, became friends with Hockney almost immediately on meeting him in 1964, and were drawn and painted by him on numerous occasions in subsequent years. They were the subject, for instance, for one of the artist's most celebrated double portraits, painted in 1968 with the couple's living room as the setting. Hockney was a frequent caller to their house by the sea and in 1984 painted a huge panoramic memory-picture based on just such an occasion, *A Visit with Christopher and Don, Santa Monica Canyon*, for which this drawing served as one of the studies. In the previous year Isherwood had published the last volume of his autobiography, *October*. He died about a year after this drawing was made. He is remembered not only for the Berlin stories of the 1930s which first established his name, but also for the plays co-written with W. H. Auden, a number of later novels, and several volumes deeply revealing of his beliefs and of the circumstances of his life. He celebrated his eightieth birthday in the year in which this portrait was drawn, and on that day *The Sunday Times* published an affectionate profile on him by his lifelong friend Stephen Spender. The poet remarked on his "seemingly unblinking eyes" and vividly described the face that fully retained its character even with the evident passing of the years: "His squarish head on which the closely cropped hair bristles, has the look of being painted sculpture,

with the incisive almost straight lines of the forehead extending round the temples, the sharp prongs of two upright lines between the thatch of the eyebrows, and the curved lines bracketing the decisive mouth."

I met Isherwood through Hockney on three occasions in 1980. On first meeting him, at a dinner party in his own house, I was so struck by his benevolent nature, warm and charming manner and easy smile that I had to remind myself that this was no longer the dashing young author of *Goodbye to Berlin* but a 75-year-old man. On seeing him again I began to notice his age — not just the wrinkles but the ebb and flow of his energy — although such matters still seemed to lie on the surface, only occasionally masking the still youthful spirit and voracious curiosity in other human beings which made him such a remarkable person. Hockney's portrait captures well Isherwood's continuing optimism in the face of life, while sparing us none of the details of the ravages of old age. In its tenderness and concern, it is as moving an image as the best of Hockney's portraits of his parents.

Jerry Sohn II — VII *1983*
(nos. 8, 22, 38, 60, 67)

Hockney's theories on moving focus and on the continuing potential of Cubist methods of picture-making are vividly demonstrated in the sequence of charcoal drawings that he made of Jerry Sohn in 1984. Sohn, who has worked for Hockney as a part-time assistant on and off over the last few years and who also works for other painters such as Sam Francis, agreed to sit for Hockney. Only the first drawing, however, was made from life, the subsequent images developing in response to each other as they were pinned up on the wall. The process was basically one of moving ever closer to the subject, examining the different facets of the face with recourse to the evidence of previous drawings and to memory. A face, Hockney reminds us, is not frozen or fixed in form as would be the case with an inanimate object, but is altered through the individual's expressions and actions and through one's own changing position in relation to him. When we form a mental image of people, it is more likely that we would imagine them not as flat and motionless but in the midst of a characteristic act. It is this kind of experience of another person for which Hockney is now intent on finding an equivalent, convinced as he is that it is not sufficient merely to record a likeness. To this end Hockney is prepared to take liberties with individual features for the sake both of expressiveness and of a convincing sensation of movement.

It took me a long time to realize that the way Picasso can draw, where you see the front and back of the figure, is not distorted, it isn't a distortion at all. Well, when you realize that, you begin to realize how in a way more real it is, you want to get involved. But it's not easy, actually, what Picasso did. That whole idea is not easy, but in a sense that's what I'm going towards, because it's more real.

As early as the second drawing of Sohn, the sitter's features have begun to be dramatically manipulated, the chin, above all, displaced from its expected position as marked by a faint outline. The next drawing directs our attention to his slightly puffy-looking cheeks, then to the contours of his nose, briefly and improbably picturing him in a seductive pose — arms raised over his head and with a come-hither expression and fluttering eyelashes — before finally presenting us boldly with a full-face image in which the sitter appears almost to be rubbing noses with us. By the end of the sequence the viewer has the sensation of having been given a guided tour of the geography of this young man's face.

David Graves Reading and Drinking *1983*
(no. 12)

David Graves made Hockney's acquaintance at the opening night of *The Rake's Progress* at Glyndebourne, Sussex, on midsummer's day 1975. Although a practicing sculptor, he was working at the time as a paper restorer at Petersburg Press with a studio almost immediately opposite Hockney's in London. By the end of the 1970s he was working directly for Hockney as an all-purpose assistant, helping with the stage sets and later with the preparation and editioning of Hockney's composite photographs.

Graves recalls that although he was doing a considerable amount of work for Hockney by 1979, it was only in 1982 or 1983 that he began to appear in the artist's drawings. "David prefers to know a person quite well before drawing them, to get to know how their face works." The portrait reproduced here was made on a visit to Monte Carlo. "I was reading a copy of *The Times* by the look of it, and I didn't even notice what was going on until after it was done. I think it was done very quickly."

The simultaneous actions of reading and drinking are captured with the aid of devices developed in Hockney's Cubist-inspired composite photographs of the period. Retaining a grasp of the sitter's identity through the shorthand identification of his hair-line and large glasses, Hockney directs our attention to the movements of the head and

hands in a kind of juggling act all the more fascinating because of its very ordinariness and familiarity. The sense of continuous movement as a series of separate actions displays the kind of realism that Hockney now sees as a primary goal: a truth to lived experience rather than simply a static recording of the appearance of a single person or object.

Henry and Eugene *1978* (no. 13)
Henry Sleeping *1978* (no. 20)

Henry Geldzahler has been an active figure in the New York art world since the early 1960s, as a friend and promoter of major contemporary artists such as Andy Warhol, as a writer and critic, as a curator at the Metropolitan Museum and later as Cultural Commissioner for New York City. Hockney got to know him quite early in his career, and still has in one of his early photograph albums a picture taken in 1963 by Dennis Hopper in which he and Warhol appear together with Geldzahler.

Henry has accompanied Hockney on some of his world travels, and the many portraits made of him, candid views of the private man rather than the public figure, are a subject in themselves. Hockney's close friends, all of whom have had to learn to take it in their stride when they are being surreptitiously drawn, enjoy telling a story which reflects not only on the personalities of both Hockney and Geldzahler but also on their playful habit of deflating each other's pretensions. Having noticed that Hockney was looking in his direction and drawing in a sketch-pad, Geldzahler obligingly began to pose and preen himself so as to put forward what he felt was his best image. Hockney would look up, squint at his companion, and return to his pad, finally standing up and walking off, leaving the pad behind him. Anxious to examine the result, Geldzahler walked across to pick up the pad to discover not the latest recording of his face but a carefully-drawn image of Mickey Mouse. Hockney the practical joker was also making a point, which is that he prefers to draw people at their ease, behaving naturally, rather than sitting stiffly as if they were having their photograph taken. Drawing people while they are asleep may seem a slight invasion of privacy, but is clearly a useful ploy in circumventing artificial stances and unwanted formality.

Cecil Beaton *1970* (no. 16)

One of Britain's most famous photographers, stage designers and society figures, Cecil Beaton also had the distinction of being one of the first people to buy a painting from Hockney, a rather racy work of 1960 titled *Adhesiveness* after Walt Whitman's term for bonding and camaraderie between men.

Hockney was still a student when he met Beaton in the early 1960s. They hit it off immediately and the young painter, something of an *enfant terrible* for his own generation, soon became a regular visitor to Beaton's home, Reddish House, at Broadchalke, Wiltshire. For Hockney it was a natural reaction on such visits occasionally to pick up a sketchbook in order to make a drawing of his host. In May 1969 he produced a group of drawings in response to a request from Beaton for a portrait to be published in *Vogue*. Hockney recalls that Beaton was going to photograph him and that he, in return, was to draw him. "I did actually probably about fifteen drawings, because if I liked it Cecil didn't, and if Cecil liked it I didn't. To get one that kind of pleased us both was not easy. I think this particular one is one that Cecil probably didn't like." The drawing reproduced here was made in the following year. In it the sharply-defined and rather handsome features, the bemused expression and even the jaunty angle of the hat all play a part in capturing the urbane public image of the man without sacrificing the sense of relaxed intimacy of the occasion.

Gregory *1978* (no. 19)
Gregory, London *1980* (no. 28)

Gregory Evans, who was for nearly a decade as much Hockney's assistant as his companion, appears in Hockney's drawings in many contrasting moods and guises, sometimes boyishly vulnerable, as in the 1976 lithograph *Gregory with Gym Socks*, sometimes withdrawn, as in the 1978 crayon drawing, or even tense and harrassed, as in the ink drawing done two years later. Hockney's portraits of him, as of other sitters, never appear to sit in judgment, but merely observe with sympathy and frankness.

Sir Isiah Berlin *1980* (nos. 21, 25, 41, 68)

Sir Isiah Berlin's distinguished academic career has included a period as a lecturer in Philosophy, as Chichele Professor of Social and Political Theory at Oxford University from 1957 to 1967, and as President of Wolfson College, Oxford, from 1966 to 1975. A Fellow of All Souls College, Oxford, his many publications include a study on *Karl Marx* (first published in 1939), *The Age of Enlightenment* (1956), *Four Essays on Liberty* (1969), *Russian Thinkers* (1978) and *Personal Impressions* (1980). He has also produced translations of Russian novels; his edition of Turgenev's *A Month in the Country* was published in 1980, the year in which Hockney's portraits of him were drawn.

Stephen Spender acted as a go-between on behalf of All Souls College, who wanted a drawing by Hockney of Sir Isiah for their collection. Like

the portrait of Harrison Birtwistle, this is one of the rare occasions in which Hockney allowed himself to be persuaded to draw someone he did not know out of a curiosity to meet the sitter. About twenty drawings resulted from sittings which took place over the course of a week. Sir Isiah was in his early seventies at the time. Hockney recalls the occasions with pleasure.

He would come and visit me. I did a few in Oxford, I even went and had lunch with him at All Souls College, which was quite amusing; he showed me all around. Otherwise he came to London and would sit talking all the time. It took me quite a time even to get likenesses, but I very much enjoyed him.

Horst Bienek (Four Quartets) *1983* (no. 23)

Horst Bienek is an East German novelist now residing in West Germany; little of his work has yet been translated into English. Hockney met him in California and assented to the writer's request for a portrait which could be printed on the dustjacket of one of his books. The sitter seems blissfully oblivious to the fact that his chair, at least as it appears in this drawing, seems in imminent danger of collapse. Such are the pleasures, it would seem, of being drawn by a master.

Bedford Sketch no. 6 *1978* (no. 24)

Kenneth Tyler, the master printer who ran the Gemini lithographic workshop in Los Angeles before setting up his own workshop near New York City, has collaborated closely with Hockney on much of his recent graphic work. In 1978 he persuaded Hockney to visit his workshop for an extended period and to try a new technique using paper pulp dipped in dyes; Hockney took to the medium with an infectious enthusiasm and produced one of his boldest and most vibrant series of images, the *Paper Pools*. This ink drawing of Tyler at work with the paper pulp is one of a group produced by him during that frantic burst of activity in a free and impetuous reed pen technique that had its roots in the work of Van Gogh and Matisse and beyond them in oriental art. It may be that Hockney's delight in discovering his own boldness with colour encouraged him simultaneously to experiment with a much looser drawing technique, in which the varying weight and organic character of the line suggests that it is now capable not only of identifying the contours of the image but also of acting as a kind of conductor of energy. In his introduction to the book published on the *Paper Pools*, Hockney commented that he had never worked with anyone with more energy than Tyler, implicitly giving him credit for inspiring him to free himself of the constraints of academic drawing and

naturalism that had temporarily held back his imaginative faculties in the mid 1970s. It was therefore a fitting tribute to Tyler to have taken him as the subject of some of the first drawings in which this dramatic change in his style was first made manifest.

Yves Marie and Mark, Paris *October 1975* (nos. 33, 34)

Yves-Marie, the subject of several drawings executed by Hockney during his extended stay in Paris from 1973 to the end of 1975, seems to personify for him the attractions of a French notion of masculinity at once softer and more sensual than one would normally encounter in English-speaking countries.

Engrossed in his reading, Yves Marie nonchalantly accepts the companionship of another young man, completely nude, as if it would not even occur to him that such an erotically-charged encounter between men were anything but the most natural and ordinary event.

Self-portraits *1983* (nos. 29, 32, 35, 36, 37, 43, 45, 52, 53, 62, 66, 71)

In 1980 I interviewed Hockney at length in preparation for the book that I was writing on his work. Why, I asked him then, had he never really drawn himself, given that many artists have maintained that they are their own ideal model, not only the cheapest but also the most patient and the most readily available?

I don't know, really. Henry Geldzahler is always urging me to do self-portraits. I think I would if I was left alone more…I think I know myself reasonably well. I think first of all you'd have to be a little more alone to do it and deal with it, which of course I'd like to be now a lot of the time.

But, I persisted, if drawing is a way of getting to know somebody, then it did seem a bit odd that he hadn't yet found the occasion to draw himself. It was as though he was stopping short of examining himself too closely.

There's something of that in it, I think, that I do stop short. I admit I avoid some things about myself, as I avoid some things about life. Violence I shy away from completely, even though I know it's possible to find some poetry there or beauty. I must admit that horrifies me, actually, probably in a way I don't know how to deal with. I think my work develops very slowly. It takes me a long time to find out things, and of course I do believe my work will get better, richer. I also assume that in the end I'll deal with things that I avoided when I was younger, partly because you will face them more, anyway.

Hockney agreed that the act of drawing people tended to bring out their more solemn aspects. Perhaps, I suggested, this helped explain why he had avoided drawing himself, that without being too conscious of it he may have been reluctant to see the black side of his own personality.

I think that's true. I know I'm going to have to deal with it soon in myself. Partly I'm aware that in the past there was a certain innocence of vision and is there still at times, but I'm also aware that perhaps it can't go on, might not go on. It's not going to change quickly, you'll sense it only when you look back at things. If you don't know how to deal with it, you put it aside, and anyway it will force itself in the end. I think if I looked at myself carefully, it would probably be the end of that innocent vision. Maybe therefore I should do it.

Hockney did eventually come to draw himself in 1983, and as is his habit, once he decided to do so he took to the subject with extraordinary zeal. For a period of about six weeks he drew himself with the help of a mirror as the first act of virtually every day. The group of thirteen drawings reproduced here are from this series of about thirty-five images produced during that period. Hockney did not think of this as a task or project; he simply decided one day that it would be interesting to do. "I just noticed that every time I looked, there was something different, and you drew it differently." He is thinking of repeating the exercise, having made some interesting discoveries about himself the first time around. "I discovered I was getting older. I discovered that my face didn't quite look how I thought without scrutinizing it. Somehow they were quite revealing to me."

A number of the self-portraits show Hockney full face, deep in concentration in the act of drawing his own image; such is the case with those of the 28th and 30th September, with *Self-Portrait with Tie*, and with *Self-Portrait with Striped Shirt* and *Self-Portrait with Check Jacket*, in both of which, as the titles suggest, his attention was attracted as much to the patterns of his clothing as to the features of his face. He looks rather askance at himself in *Self-Portrait with Striped Shirt and Tie*, and in his drawing of the 26th September he looks rather stern and weary, still brandishing his drawing tools as the proud emblem of his vocation. On occasion, as in *Self-Portrait from the Side*, his curiosity is directed to looking at himself from uncharacteristic angles, literally seeing himself as others might see him. One of the most moving aspects of this series is the honesty with which he represents his own occasional bouts of depression, as in the dejected expression of his *Self-Portrait with Cigarette* or the *Self-Portrait with Finger Behind Glasses*. It is curiously comforting to know that even someone with such a sunny dis-

position sometimes experiences such moods, or looks as scruffy and bleary-eyed the first thing in the morning as he did on the 25th October — though, unlike most of us, he was able to improvise a bleary-looking system of notation which articulated with great wit and control his difficulties in focussing his eyes on that particular occasion. What I value above all in these drawings is Hockney's avowal of our common humanity, his readiness to depict himself with the same honesty and casual forthrightness that has always marked his portraits of others.

Peter Asleep, Dream Inn, Santa Cruz *1966* (no. 40)
Peter Schlesinger *1978* (no. 63)
Abuo Shakra Restaurant, Cairo, *1978*

Peter Schlesinger was an 18-year-old student at UCLA when Hockney met him while teaching there in 1966. From 1966 to 1971, Peter was the artist's preferred model, embodying both an ideal and reality. As Hockney recalled in 1980, "It was incredible to me to meet in California a young, very sexy, attractive boy who was also curious and intelligent. In California you can meet curious and intelligent people, but generally they're not the sexy boy of your fantasy as well. To me this was incredible; it was more real. The fantasy part disappeared because it was the real person you could talk to."

The mood of *Peter Asleep, Dream Inn, Santa Cruz* corresponds well to the name of the motel in which they were staying. So strong is the atmosphere of somnolence and reverie that it seems as though the crayoned areas of vivid colour above the sleeper's head are the product of his own subconscious imagination, rather than simply the boundary of an ordinary room. The solidity and boldness of the colour contrasts sharply with the delicacy of the pencil line by which the figure has been conjured onto the page, the sensuousness of his skin merging with the tactility of the paper on which his image has materialized.

Peter has remained one of the artist's most valued friends. Early in 1978 he was one of a group of friends who travelled with the artist to Egypt, the main purpose of the journey being to produce drawings and photographs that could serve as source material in preparing designs for the new production of Mozart's *The Magic Flute*, to be staged at Glyndebourne Opera House in May of that year. The portrait of Peter in *Abuo Shakra Restaurant, Cairo*, made during this visit, makes for an interesting comparison with the other portrait of him reproduced here, also dating from 1978. If I recall correctly, these are the very drawings that the artist showed me in 1980 as evidence of his concern to capture different facets of someone's personality:

evidence of his concern to capture different facets of someone's personality:

Look at these two drawings of Peter. There's a lot of difference in those faces, isn't there? They're both like him in a way, anybody that knows him would recognize the faces. This is the kind of petulant side of Peter, and the other is the kind of innocent sweetness.

Leon Banks *1967* (no. 42)

Leon Banks, a Los Angeles pediatrician and art collector, lived near Hockney at the time that this was drawn and was a frequent visitor to his studio. He tried for many years to persuade the artist to paint his portrait, but, Hockney recalls today, "I told him I didn't really do portraits just like that." Banks did eventually get his wish over the winter of 1979/80 when he posed for one or two drawings and a full-length seated portrait painted in acrylics on cardboard.

Harrison Birtwistle *1970* (no. 48)

The curious but slightly wary expression on the face of this leading British composer, in his mid-thirties at the time, reveals something of the circumstances which prompted this and associated drawings. It was Hockney's first meeting both with Birtwistle and with another highly respected composer of the same age, Peter Maxwell Davies. Peter Heyworth, the music critic of *The Observer*, who in 1968 had introduced the artist to the poet W. H. Auden for a similar drawing session, asked Hockney if he would be interested in drawing the two musicians, who were good friends at the time, both separately and as a double portrait. Hockney knew and liked their music and therefore consented to the proposal. Birtwistle's quizzical glance, his right eye half shut as he scrutinizes the artist scrutinizing him, hints at the reflective nature of the act which has brought together artist and sitter, and which by extension places the viewer in a similarly uncomfortable position of being examined.

Claude Bernard *1975* (no. 51)

This rather formal study of the French art dealer Claude Bernard was made in the same year that Hockney had an exhibition of drawings and prints in his Paris gallery. In contrast to the many portraits over the years of the artist's British dealer, Kasmin — at their best casual, affectionate and even humorous in tone — this is an image of businesslike severity and aloofness, an avowal of a correct but detached relationship.

Mo McDermott *1983* (no. 56)

Mo McDermott, himself an artist, was part of Hockney's circle of friends in London in the 1960s and worked for him as an assistant on his paintings during the late 1960s and early 1970s. He has made sporadic appearances as a subject in Hockney's work as well as in the 1974 film made by Jack Hazan, *A Bigger Splash*. He was the standing nude in one of Hockney's most engaging early double portraits, *Domestic Scene, Notting Hill* 1963, and in the previous year, shortly after they had met, he had already served as the model for one of Hockney's last student canvases, *Life Painting for Myself*. This much later portrait was drawn in Los Angeles, where he now lives.

Albert Clark, Los Angeles *August 1981* (no. 58)

Children appear rarely in Hockney's work, not because he would find it too sentimental to use them as subjects but because they do not figure very largely in his life or in his circle of friends. An exception to this rule are the two sons of Celia Birtwell and Ossie Clark, whom Hockney has watched grow up and whom he has periodically invited to stay with him in California. While capturing the slightly chubby appearance of a young adolescent's face, Hockney otherwise treats this serious-looking boy not as a child but as a personality emerging into adulthood.

Billy Wilder *1983* (no. 69)

It was at the end of 1963 that Hockney first went to Los Angeles, and in spite of his travels and periods of residence elsewhere he has continued to regard it as his main home. Contrary, however, to the expectations that one might have of this art world star, Hockney has never had much contact with glittering Hollywood society. Although a great fan of Billy Wilder's movies, in particular such masterpieces as *Some Like it Hot* and *Sunset Boulevard*, it was in fact at the director's instigation that they met in the early 1970s. "He likes pictures, he likes artists. He looked me up, and I enjoyed him enormously." Hockney published a lithographic portrait of him in 1976, and they have continued ever since to meet socially, to share jokes and to talk about life in general. A glimmer of Wilder's wisecracking personality can be detected not only in the rakish way in which he sports his hat, but also in the trace of a sly smile that he seems unable to suppress even for the sake of appearing duly serious to posterity.

President, Loyola Marymount University James N. Loughran, S.J.
Academic Vice President Albert P. Koppes, O.Carm.
Dean, College of Communications and Fine Arts Warren Sherlock
Director, Laband Art Gallery Ellen Ekedal
Catalogue Designers David Hockney, Charlie Scheips
Catalogue Production Vernon Tokita
Photography Richard Schmidt